# ART OF COLORING

## 100 IMAGES TO INSPIRE CREATIVITY

# ART OF COLORING

## Disney

# MICKEY & MINNIE

### 100 IMAGES TO INSPIRE CREATIVITY

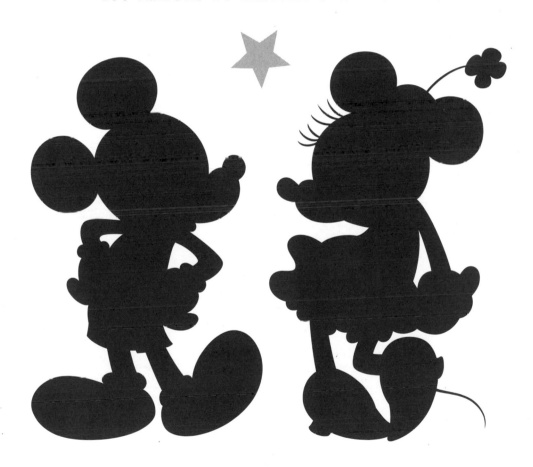

## Disney
### EDITIONS
Los Angeles · New York

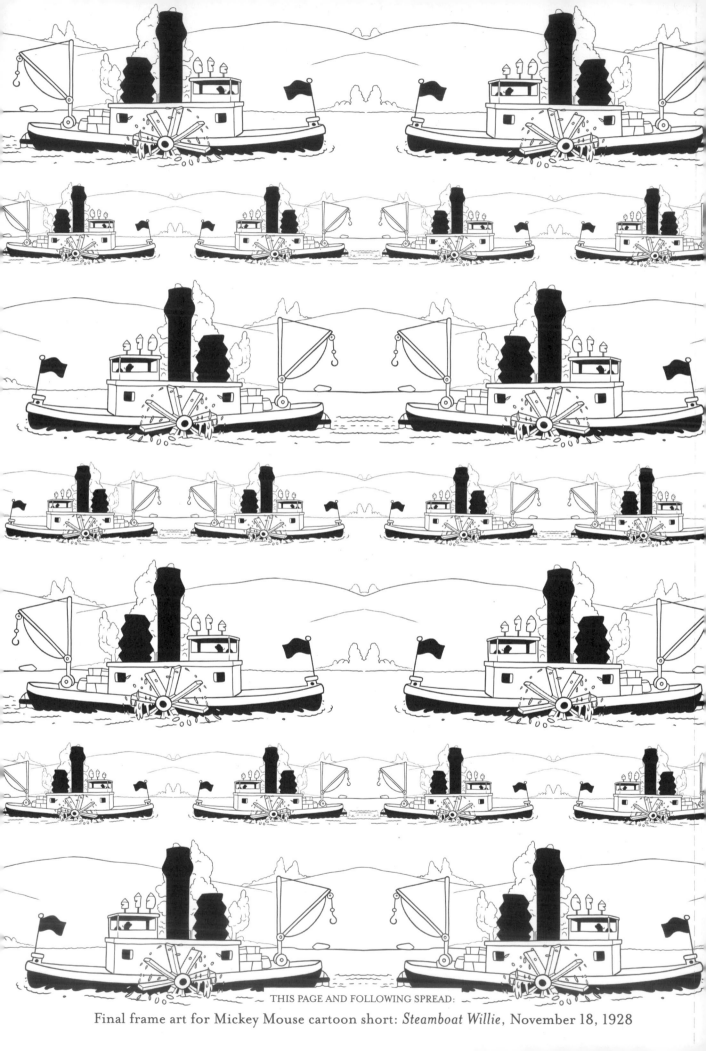

THIS PAGE AND FOLLOWING SPREAD:

Final frame art for Mickey Mouse cartoon short: *Steamboat Willie*, November 18, 1928

1970s rerelease poster for Mickey Mouse cartoon short: *Steamboat Willie*, November 18, 1928

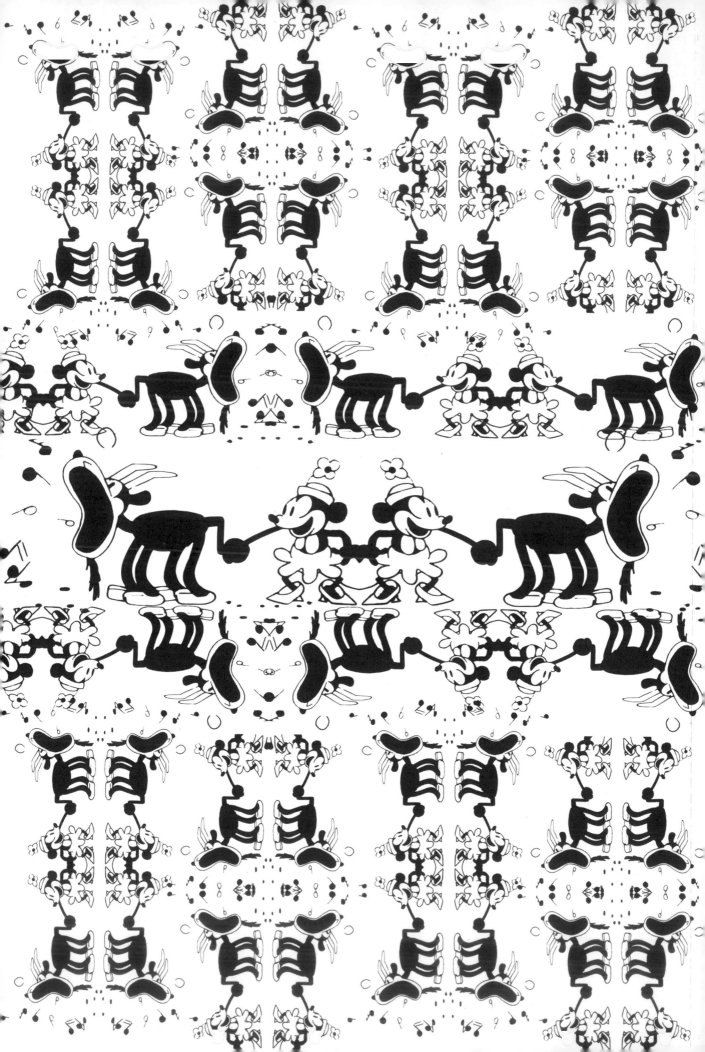

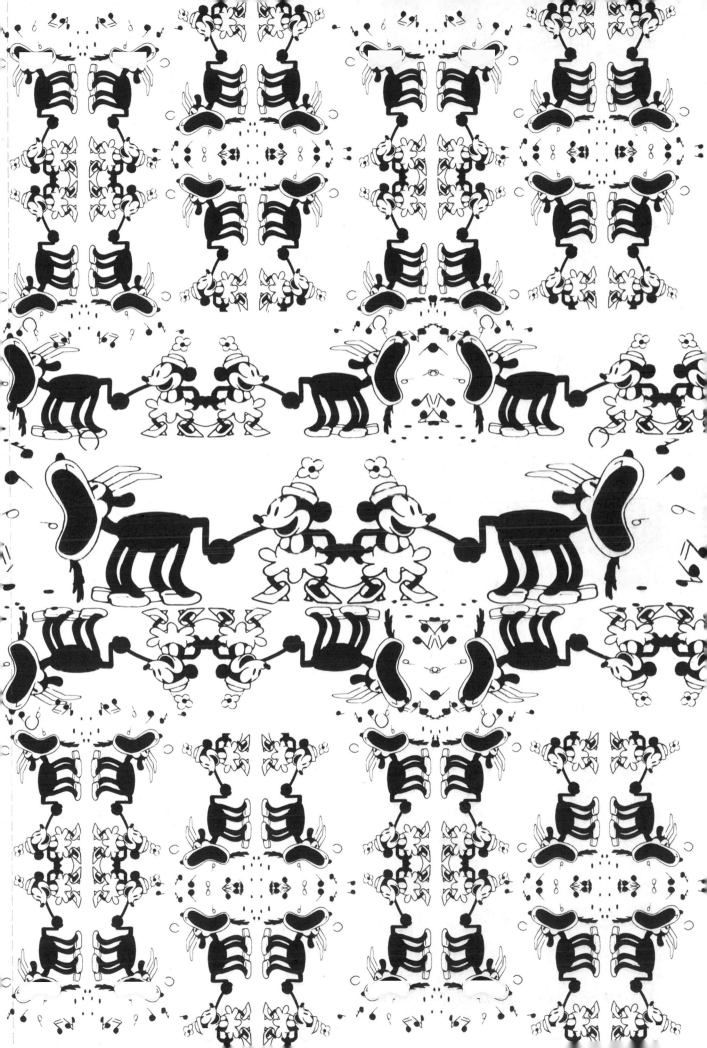

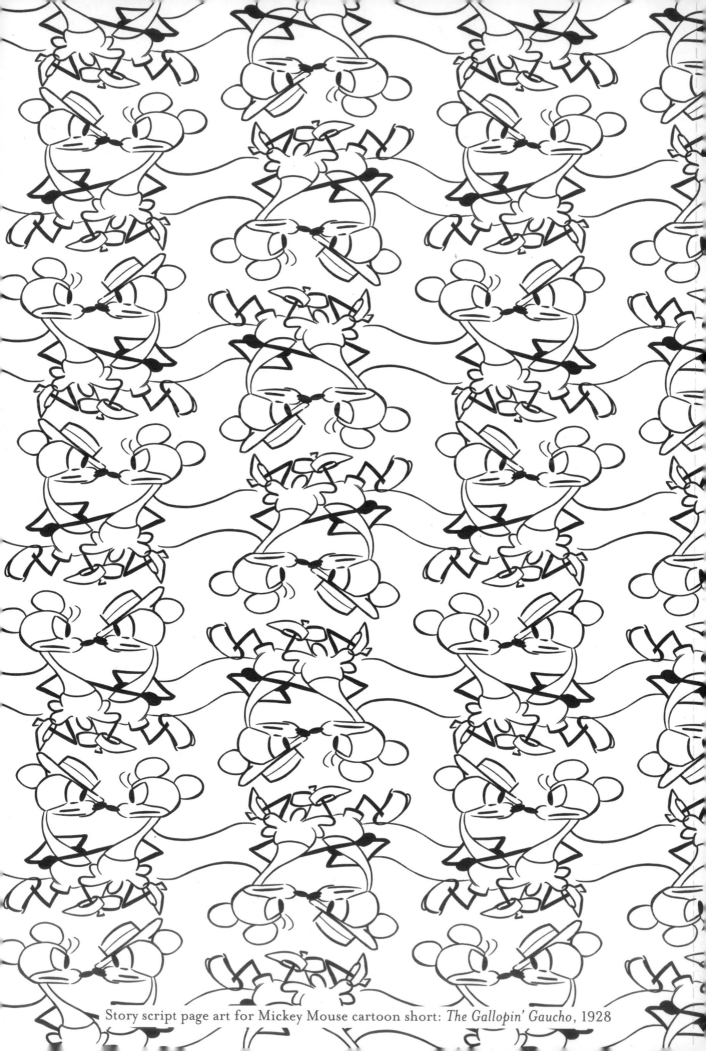

Story script page art for Mickey Mouse cartoon short: *The Gallopin' Gaucho*, 1928

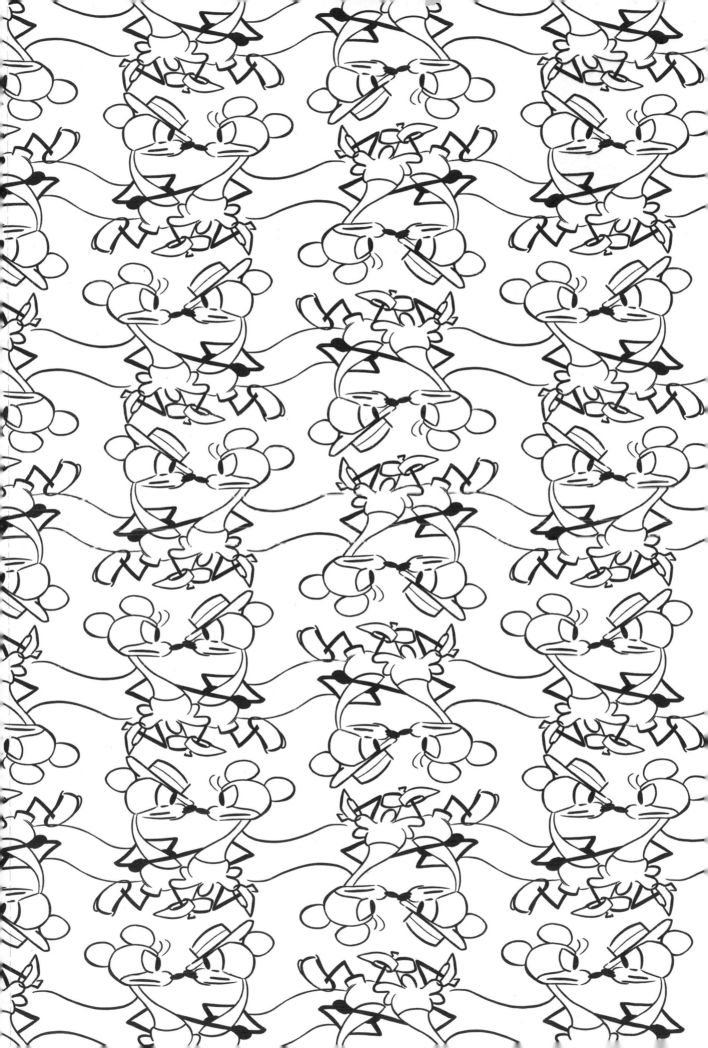

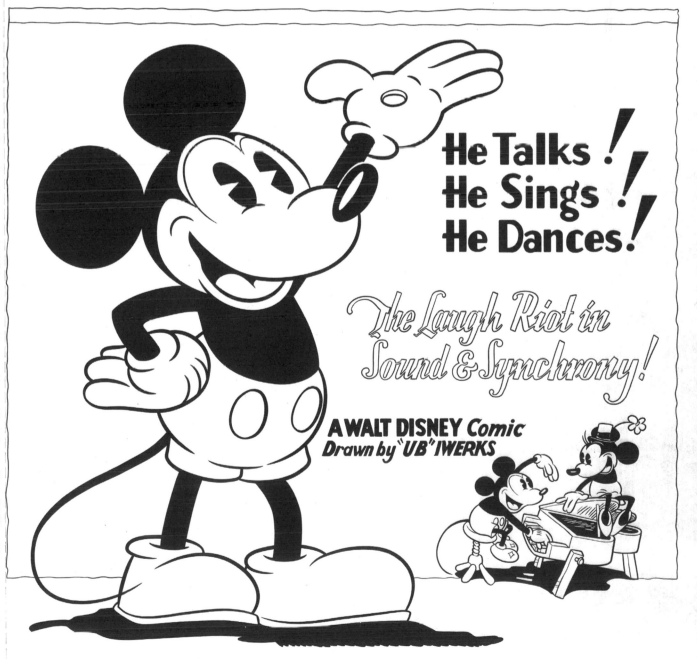

Poster for Mickey Mouse cartoon short: *Wild Waves*, 1929

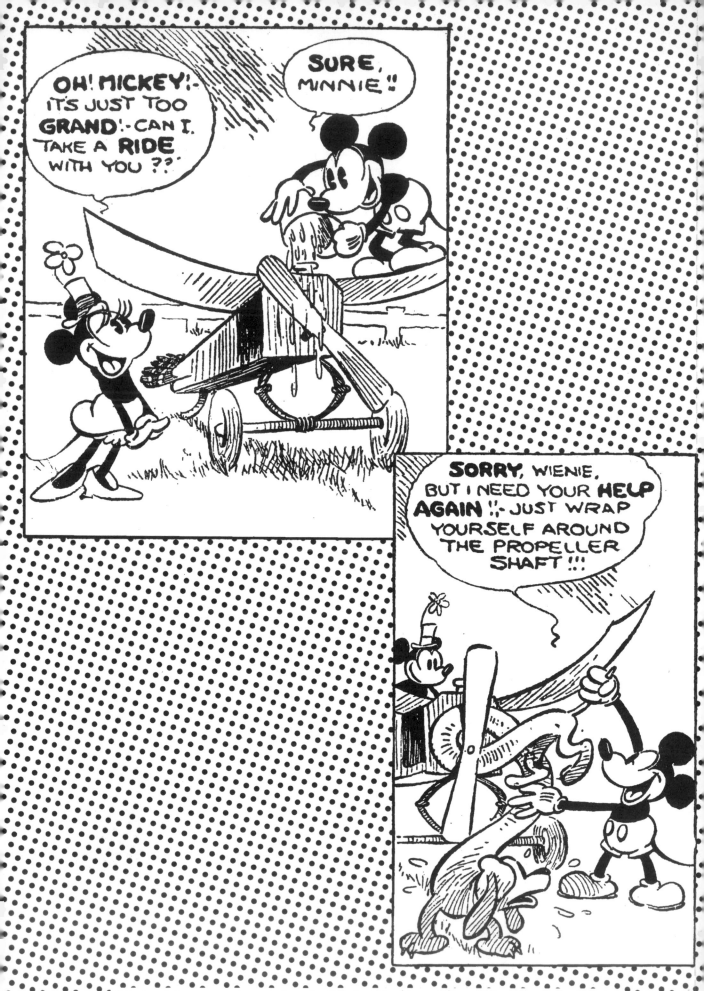

Mickey Mouse comic panel art by Ub Iwerks (pencils) and Win Smith (inks):
"Lost on a Desert Island," January 1930

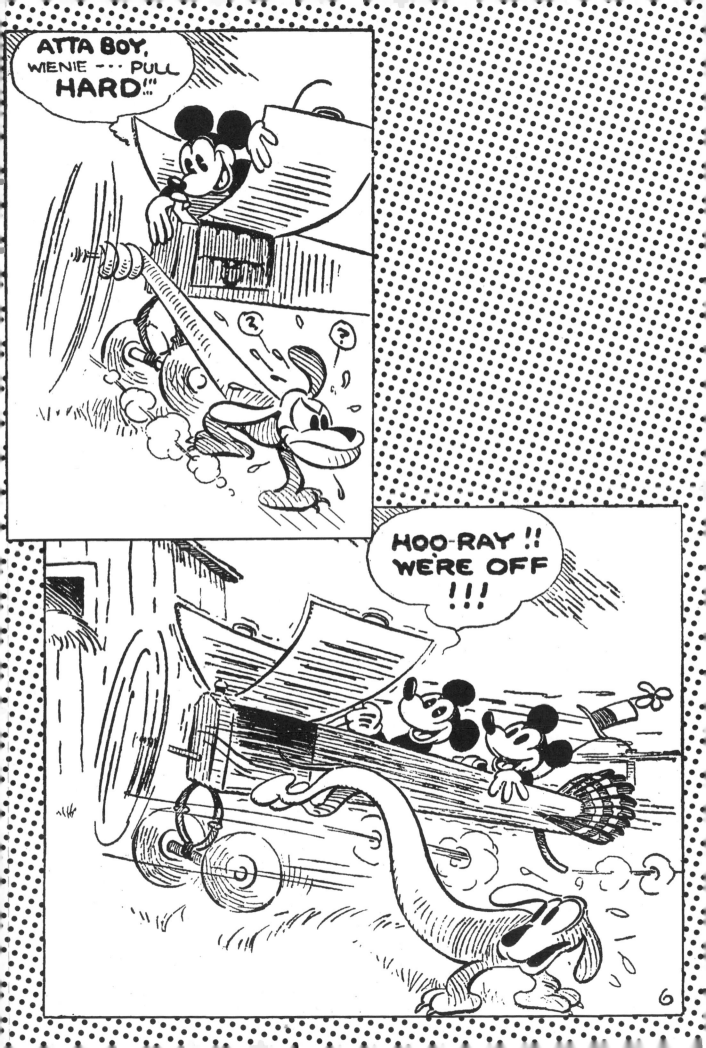

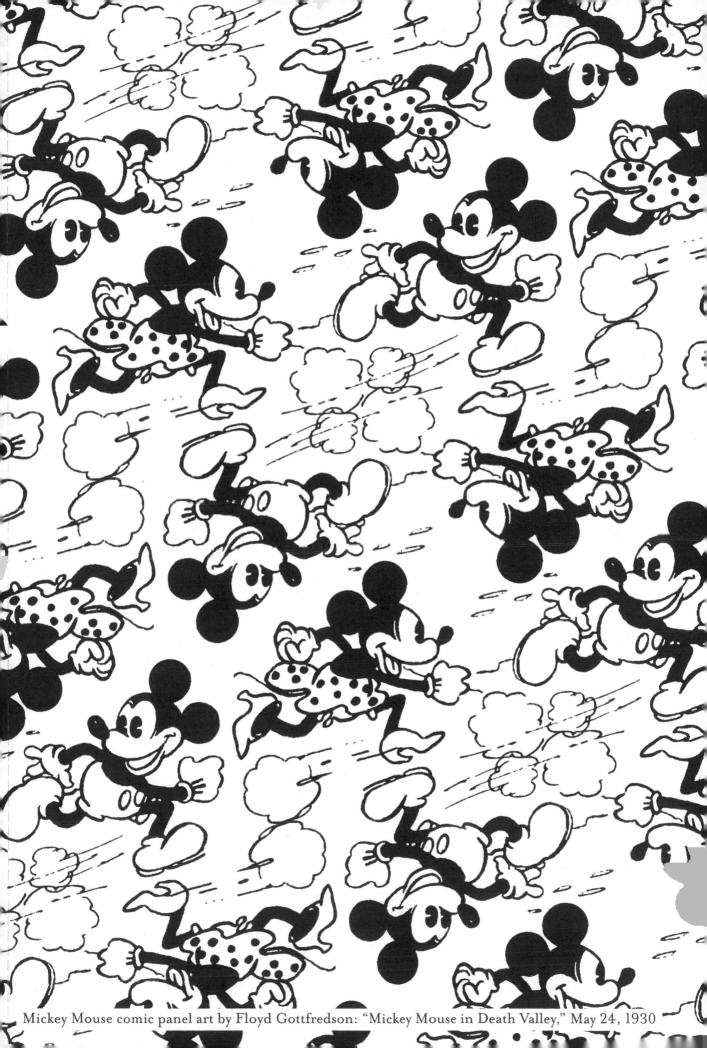

Mickey Mouse comic panel art by Floyd Gottfredson: "Mickey Mouse in Death Valley," May 24, 1930

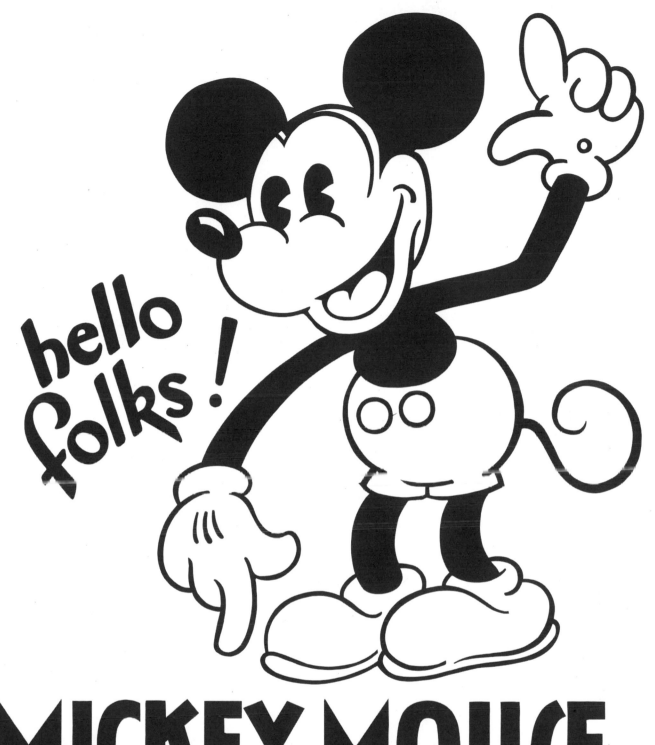

Poster for Mickey Mouse cartoon short: *The Shindig*, July 29, 1930

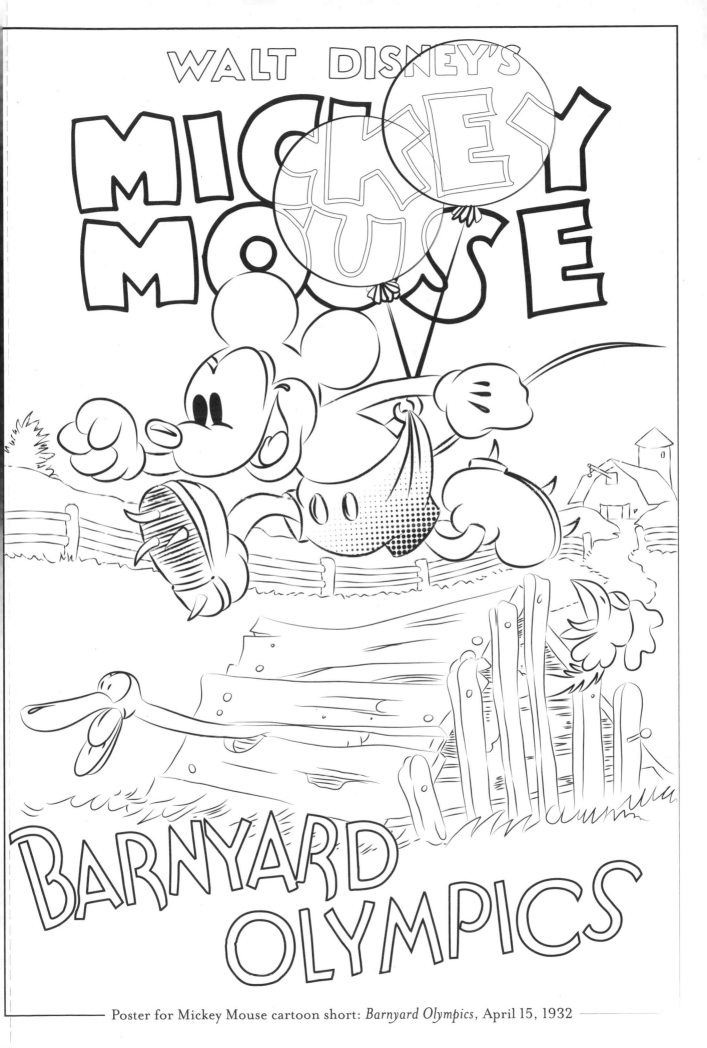

Poster for Mickey Mouse cartoon short: *Barnyard Olympics*, April 15, 1932

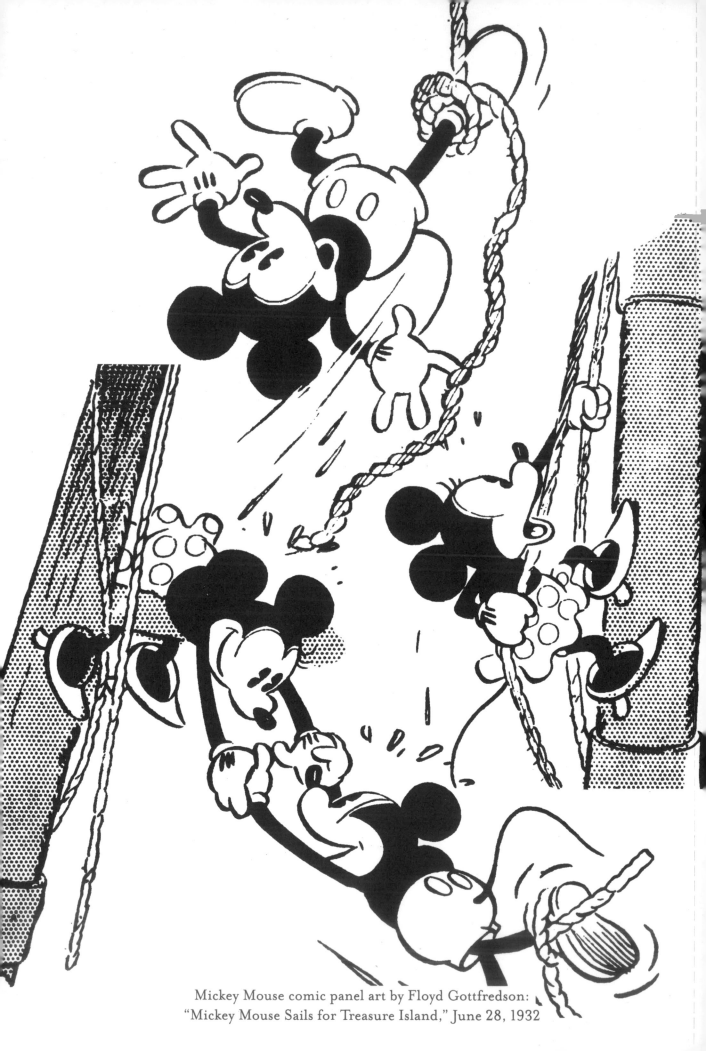

Mickey Mouse comic panel art by Floyd Gottfredson:
"Mickey Mouse Sails for Treasure Island," June 28, 1932

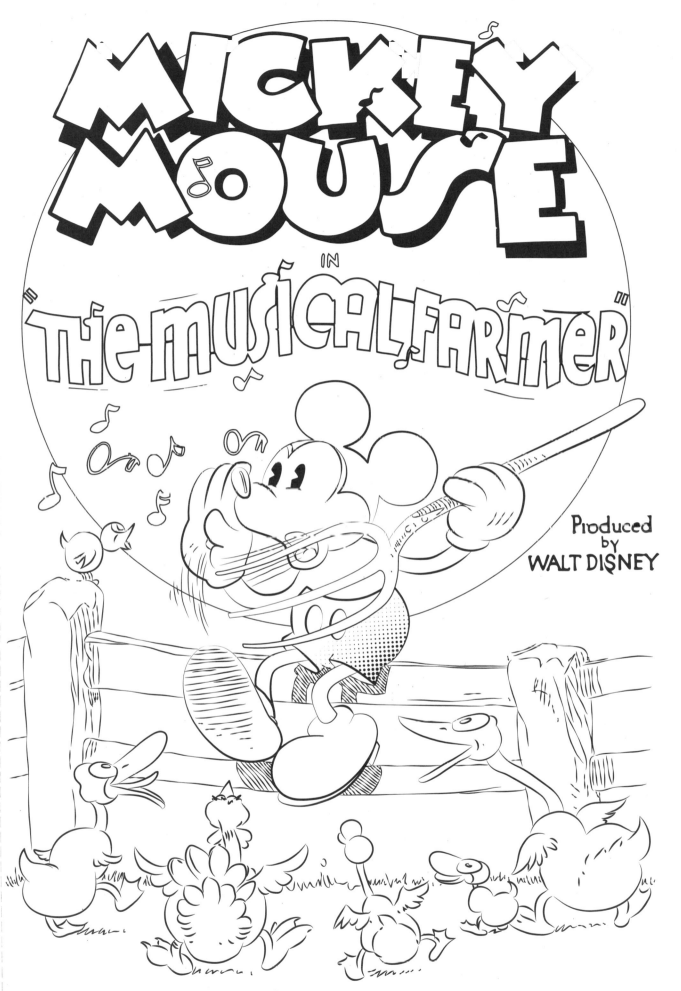

Poster for Mickey Mouse cartoon short: *The Musical Farmer*, July 9, 1932

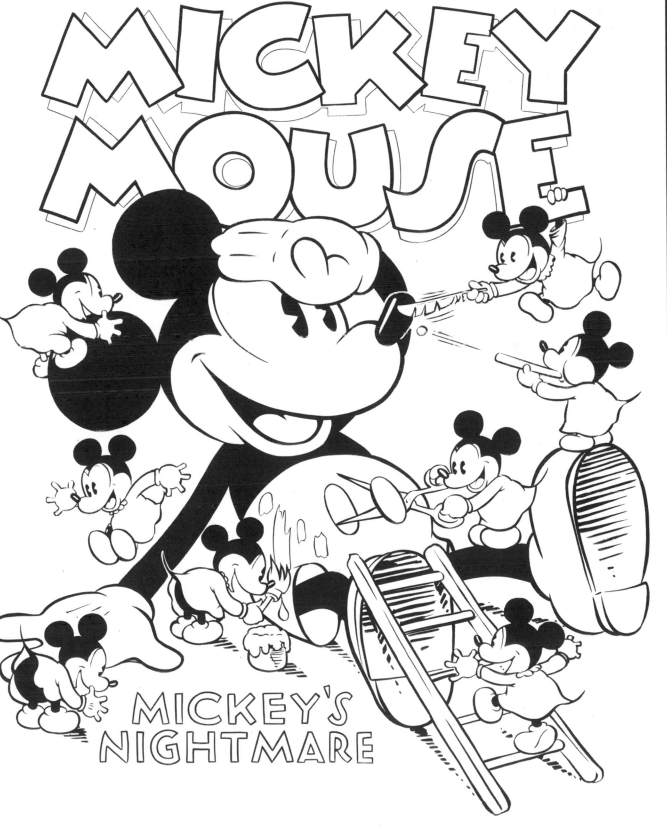

Poster for Mickey Mouse cartoon short: *Mickey's Nightmare*, August 13, 1932

Poster for Mickey Mouse cartoon short: *The Whoopee Party*, September 17, 1932

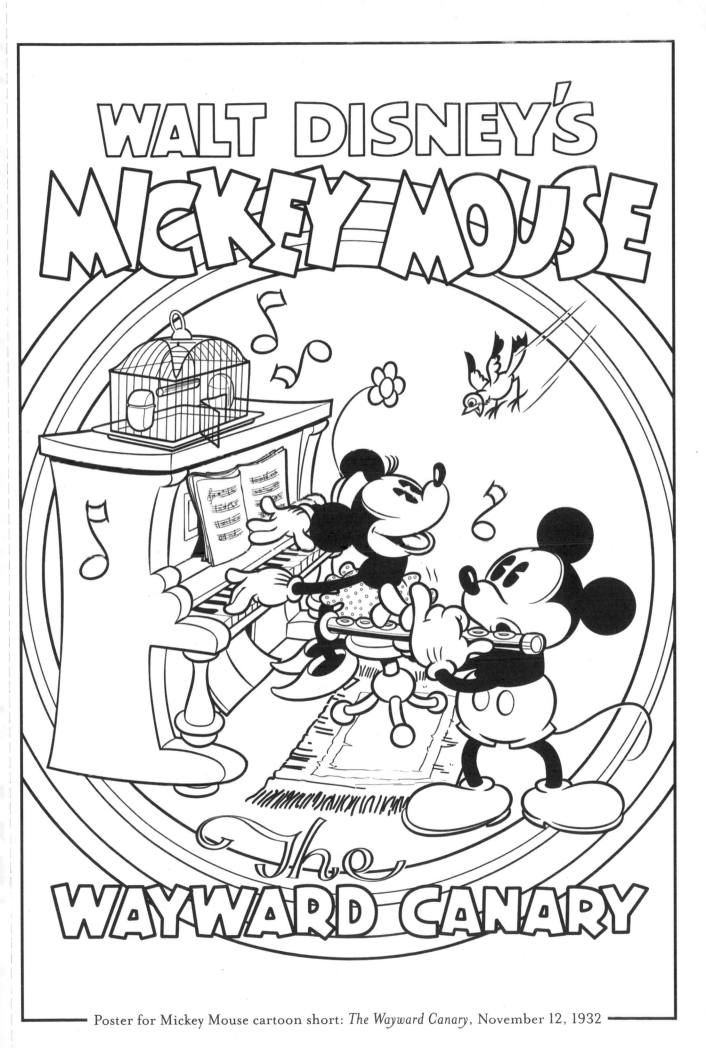

Poster for Mickey Mouse cartoon short: *The Wayward Canary*, November 12, 1932

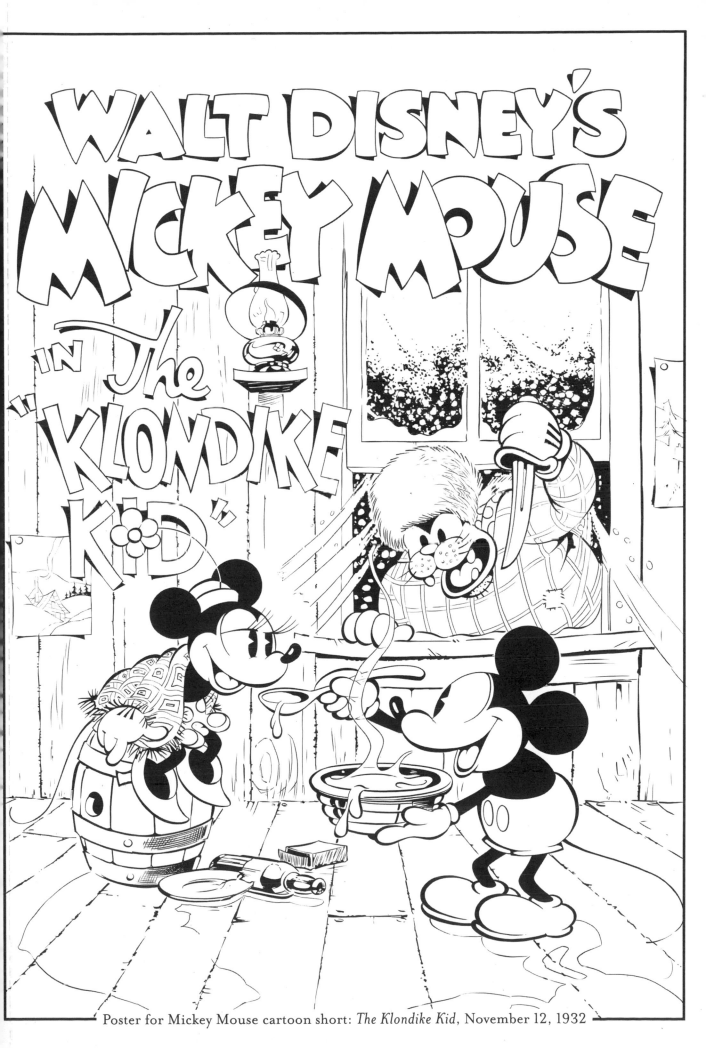

Poster for Mickey Mouse cartoon short: *The Klondike Kid*, November 12, 1932

Poster for Mickey Mouse cartoon short: *Mickey's Good Deed*, December 17, 1932

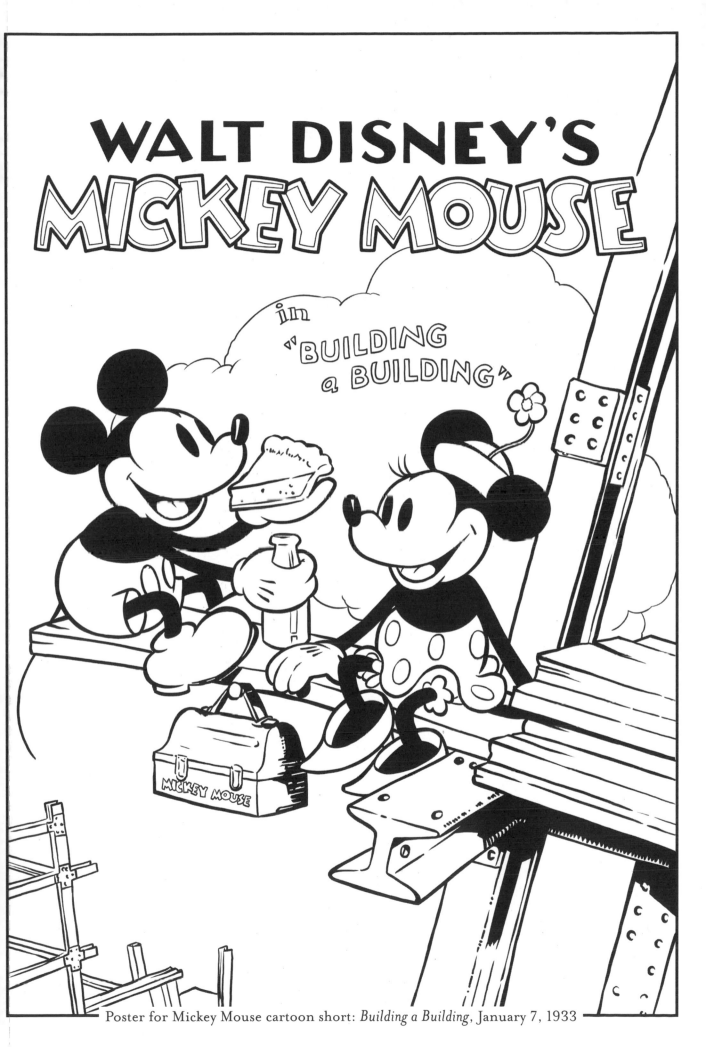

Poster for Mickey Mouse cartoon short: *Building a Building*, January 7, 1933

Mickey Mouse comic panel art by Floyd Gottfredson: "Blaggard Castle," January 17, 1933

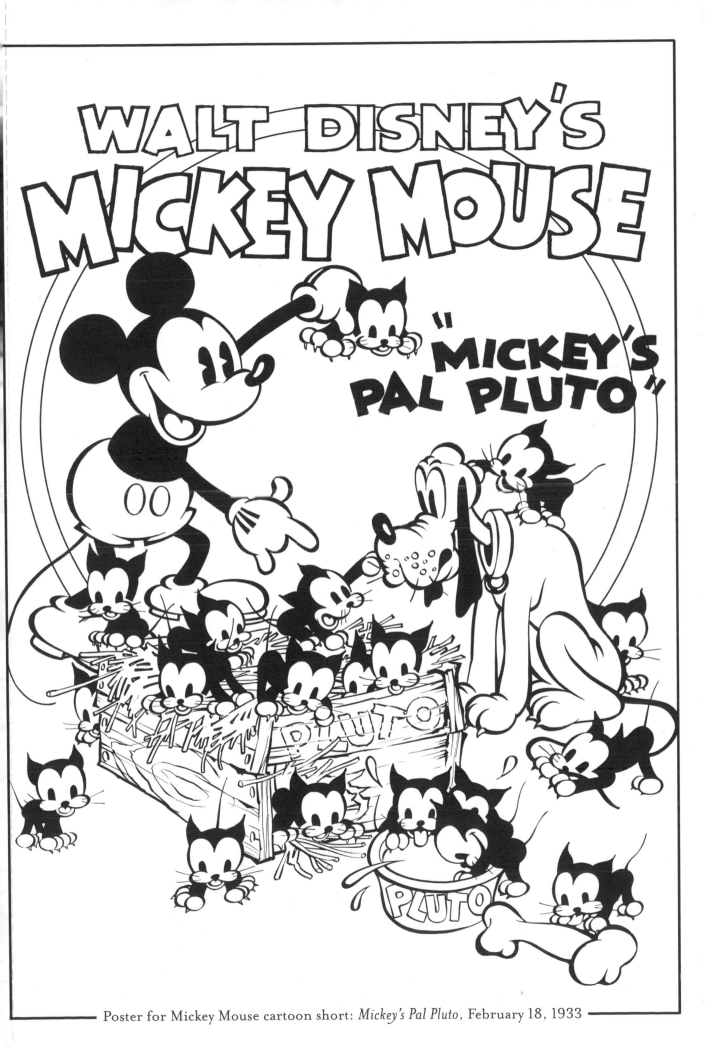

Poster for Mickey Mouse cartoon short: *Mickey's Pal Pluto*, February 18, 1933

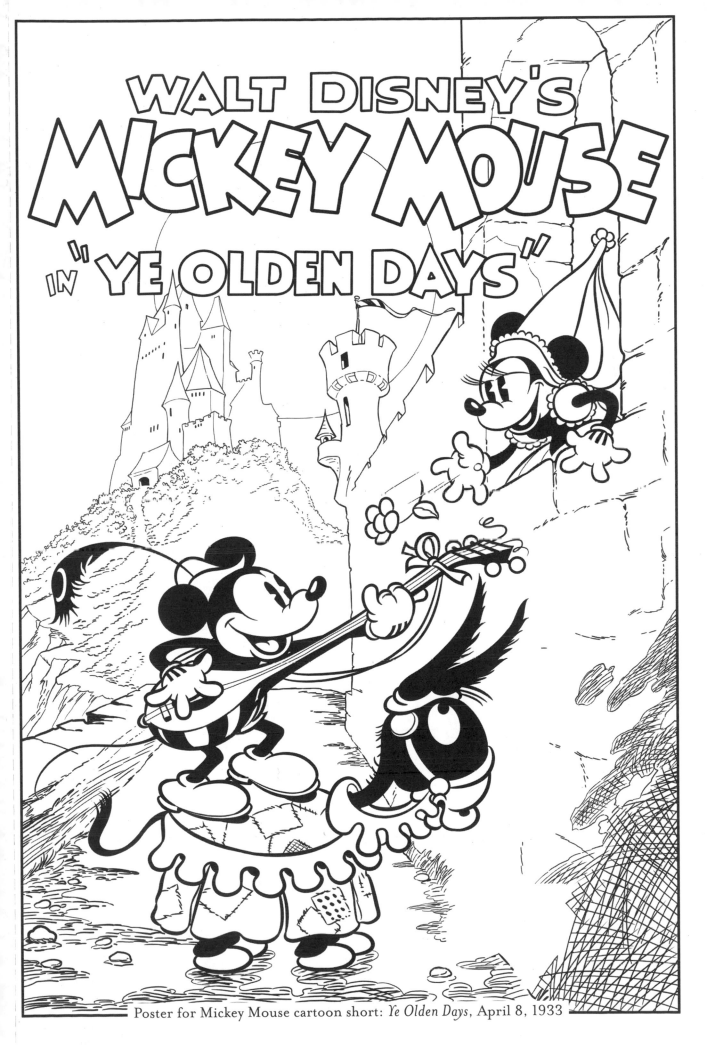

Poster for Mickey Mouse cartoon short: *Ye Olden Days*, April 8, 1933

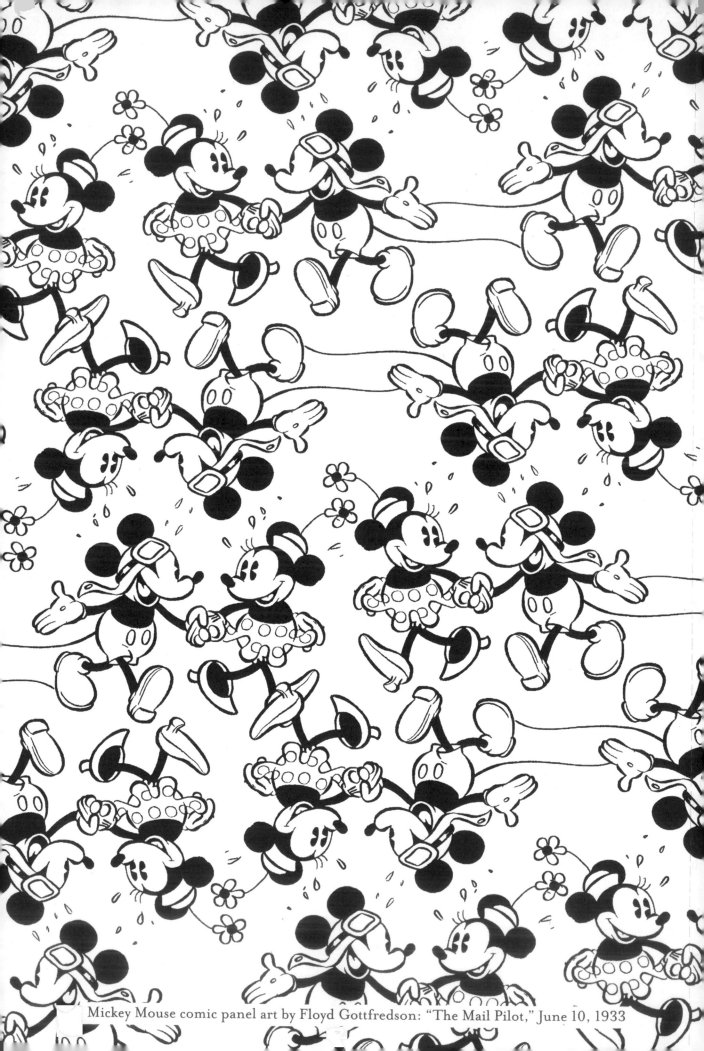

Mickey Mouse comic panel art by Floyd Gottfredson: "The Mail Pilot," June 10, 1933

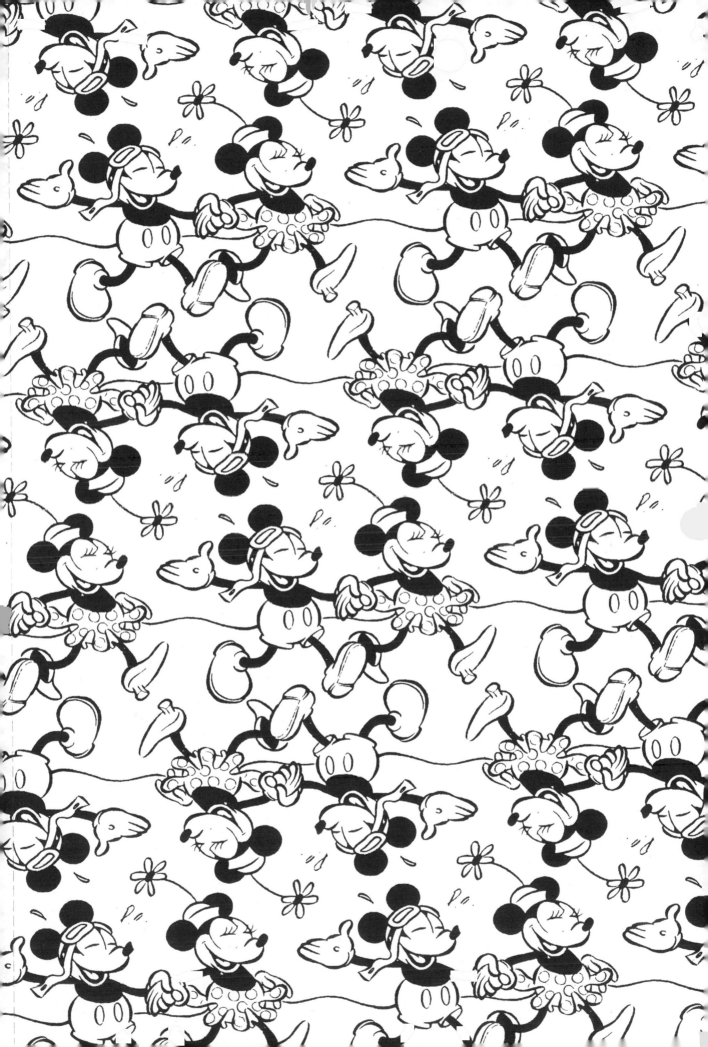

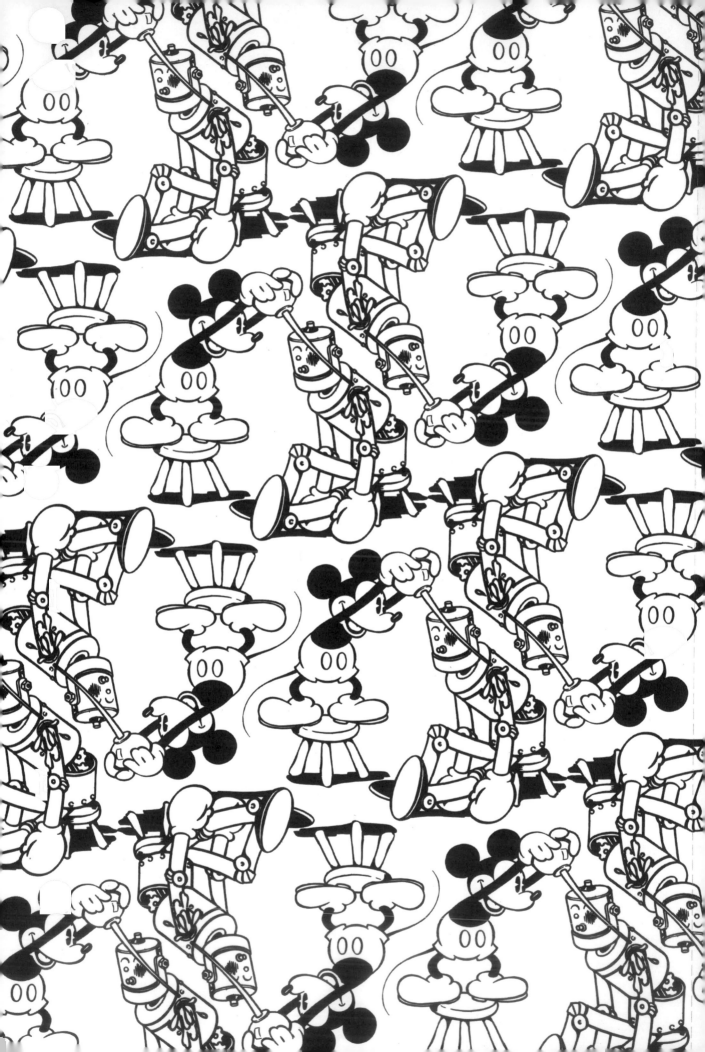

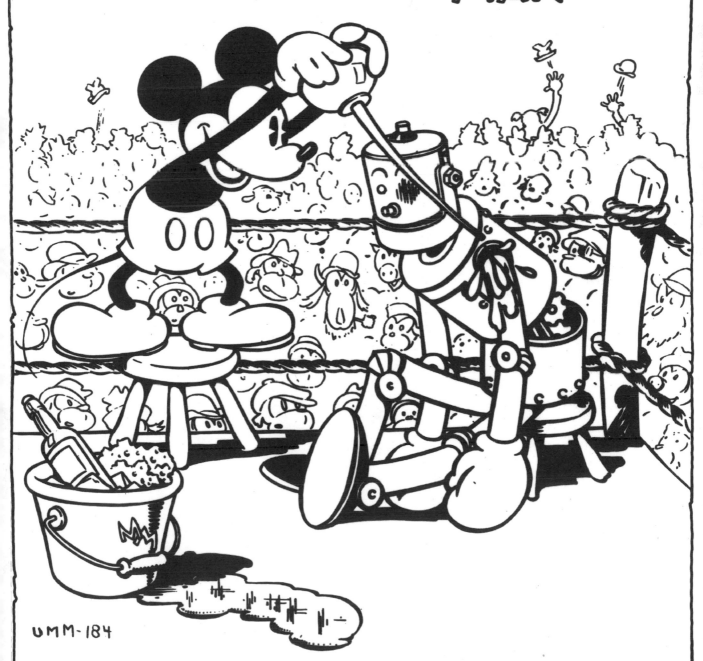

Poster for Mickey Mouse cartoon short: *Mickey's Mechanical Man*, June 17, 1933

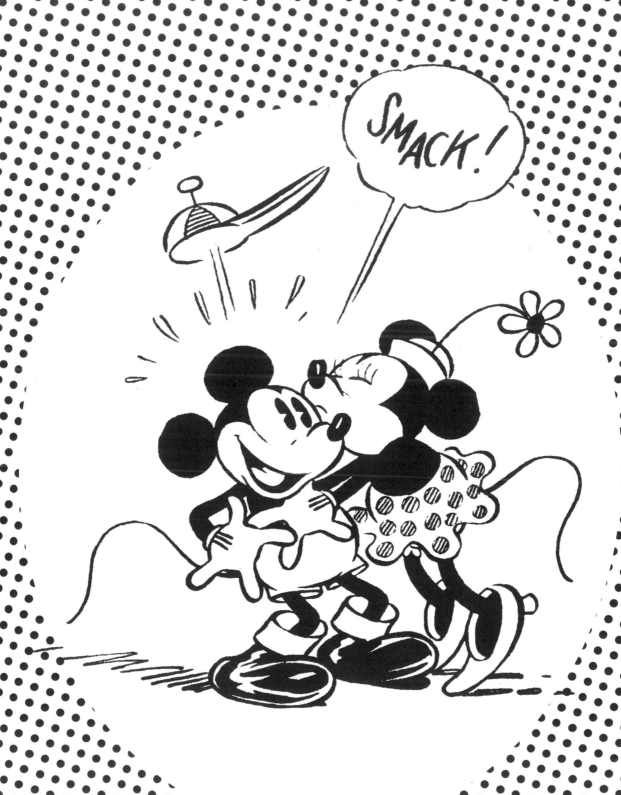

Mickey Mouse comic panel art by Floyd Gottfredson:
"Mickey Mouse and His Horse Tanglefoot," October 3, 1933

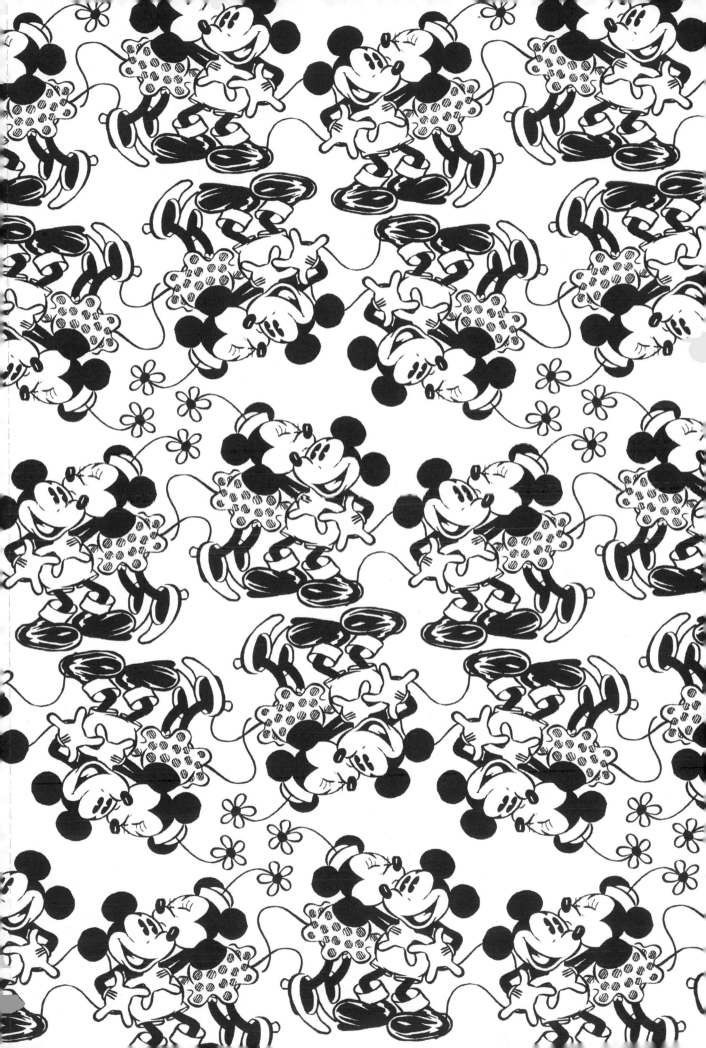

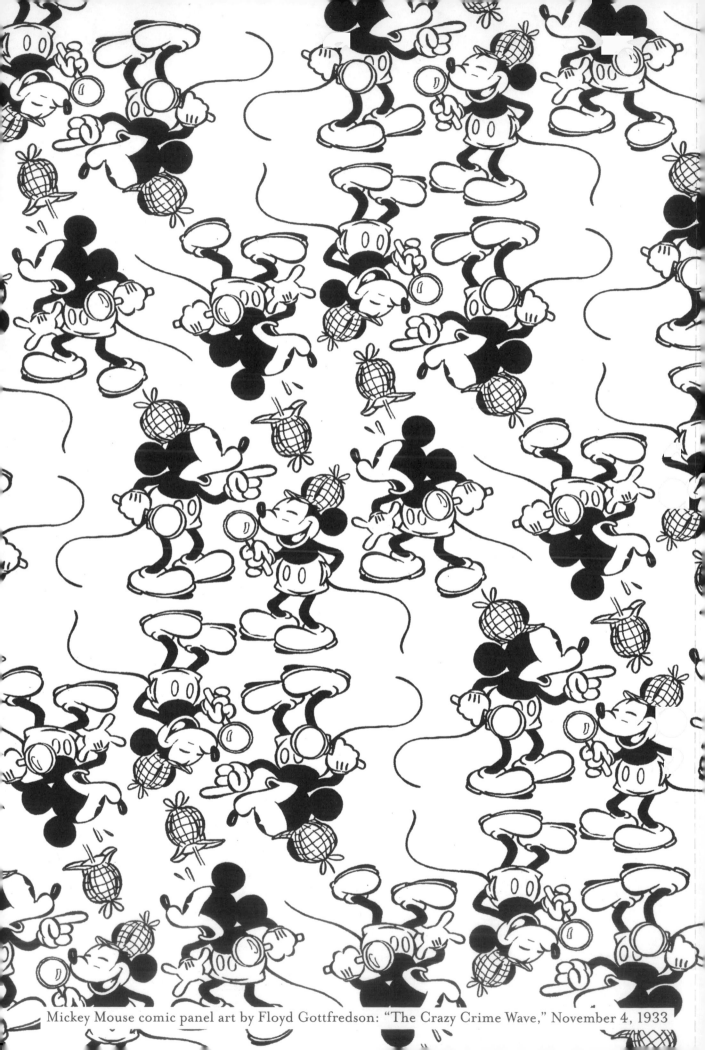

Mickey Mouse comic panel art by Floyd Gottfredson: "The Crazy Crime Wave," November 4, 1933

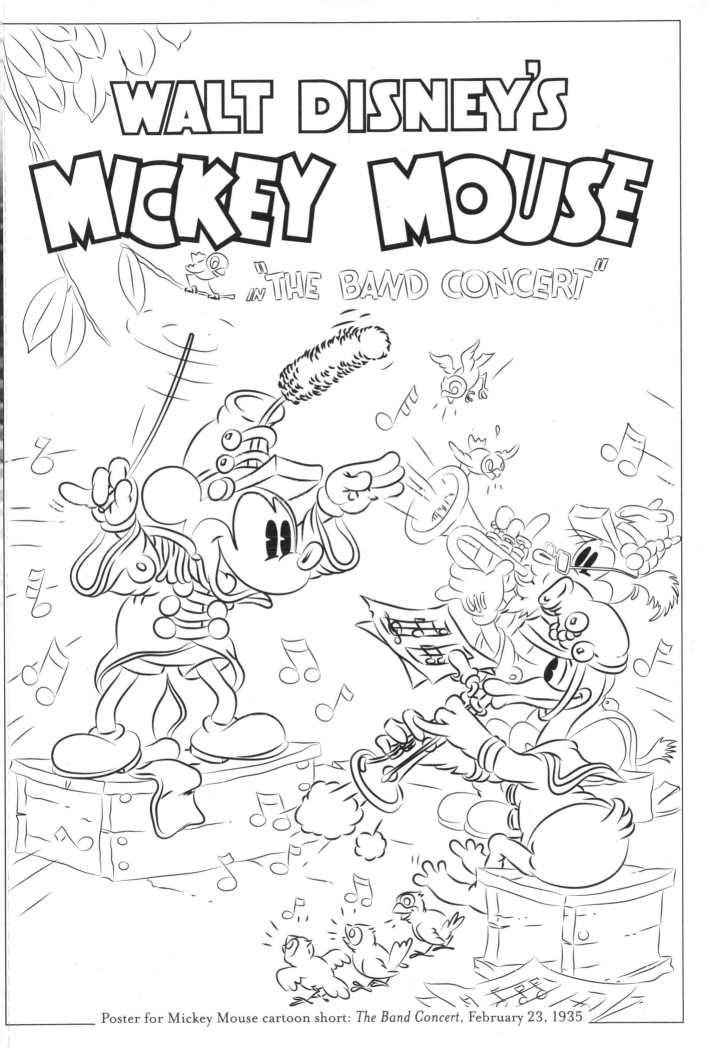

Poster for Mickey Mouse cartoon short: *The Band Concert*, February 23, 1935

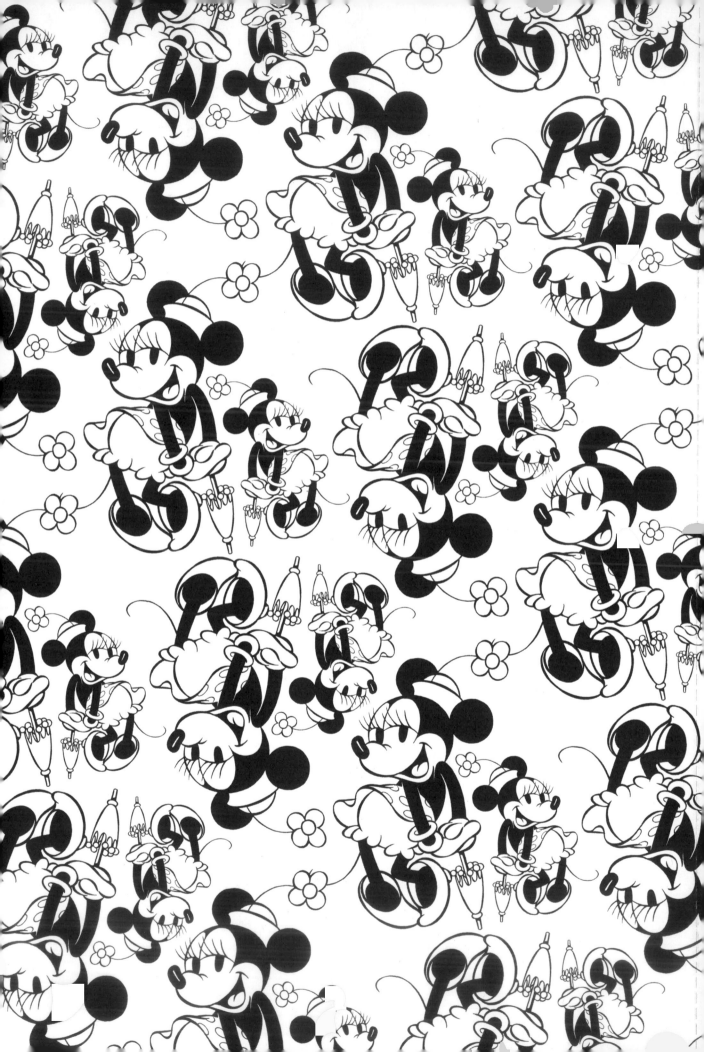

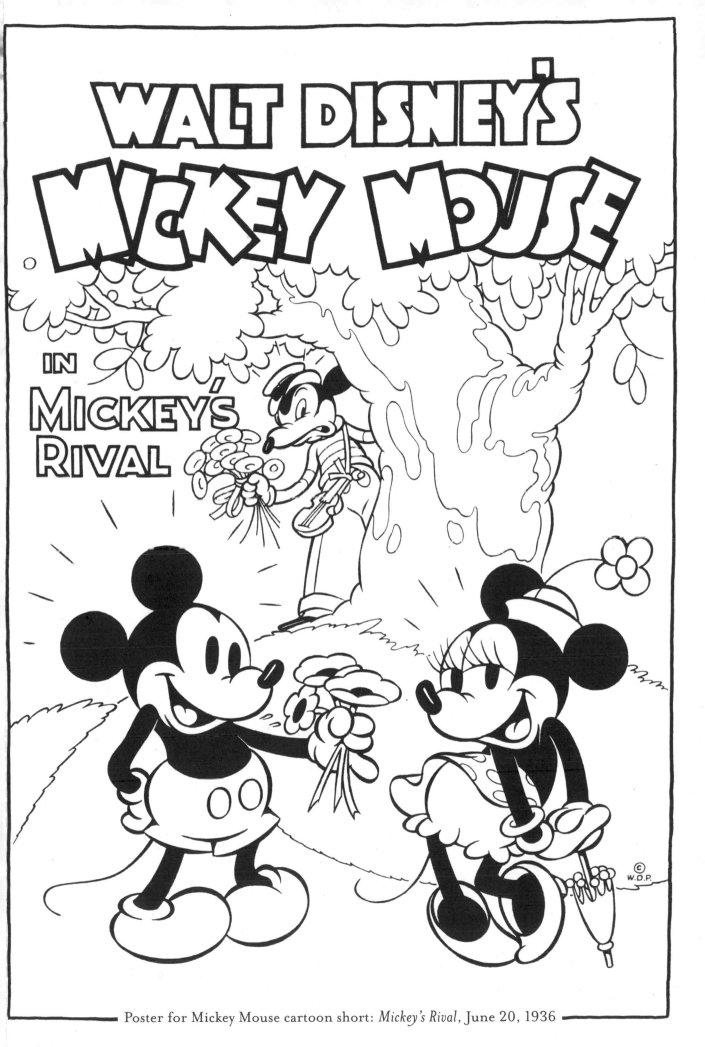

Poster for Mickey Mouse cartoon short: *Mickey's Rival*, June 20, 1936

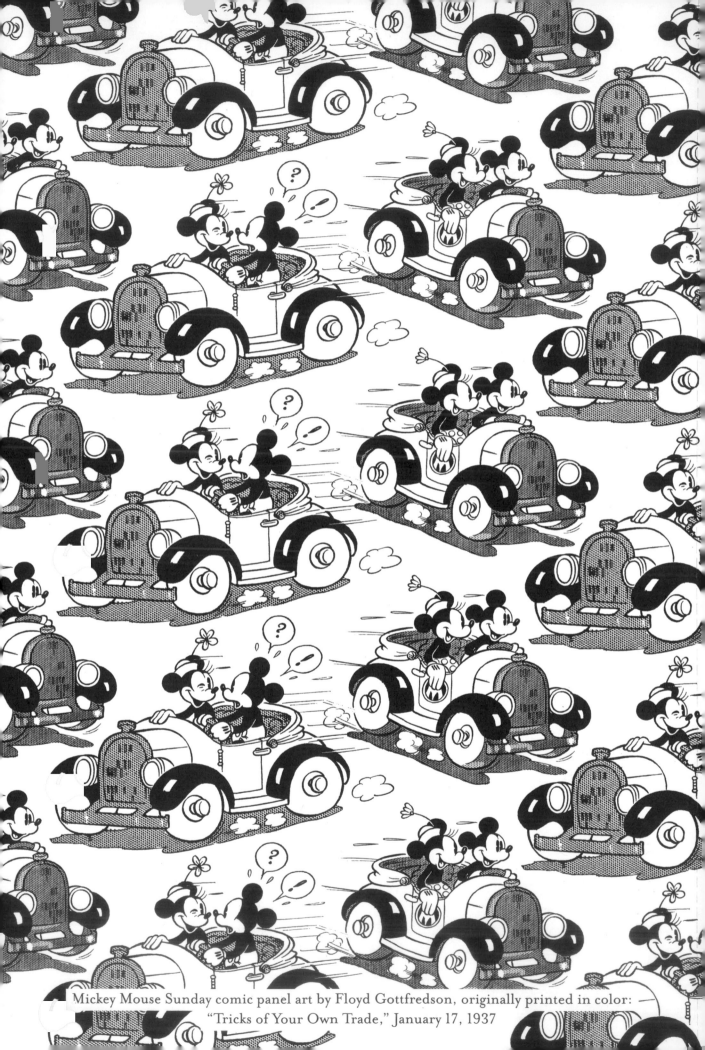

Mickey Mouse Sunday comic panel art by Floyd Gottfredson, originally printed in color: "Tricks of Your Own Trade," January 17, 1937

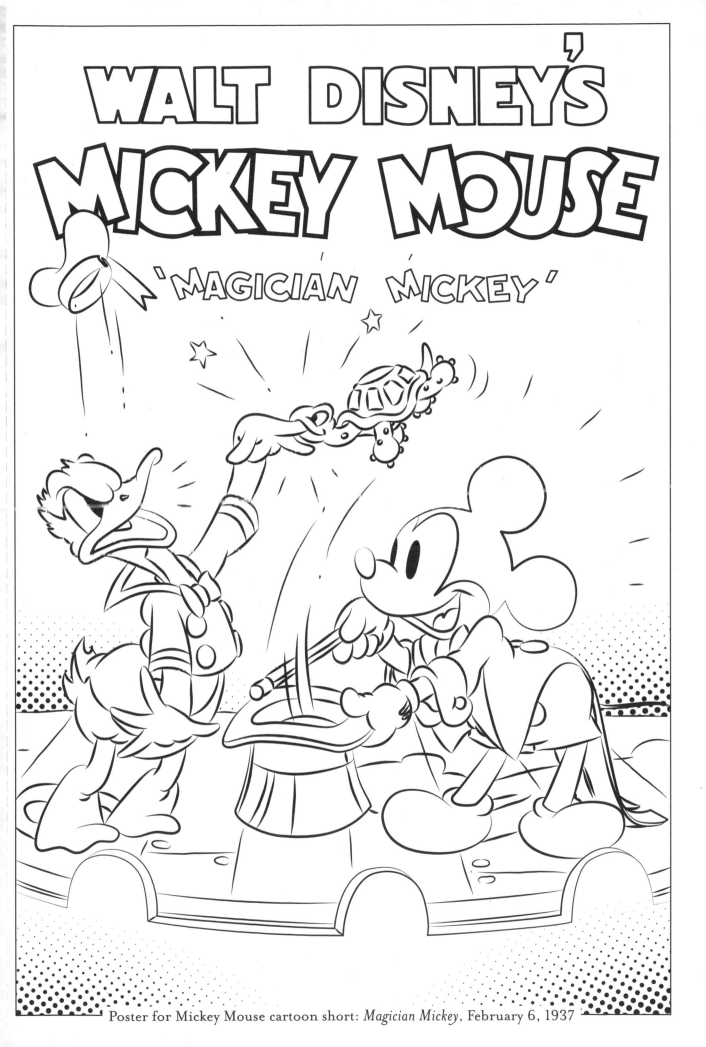

Poster for Mickey Mouse cartoon short: *Magician Mickey*, February 6, 1937

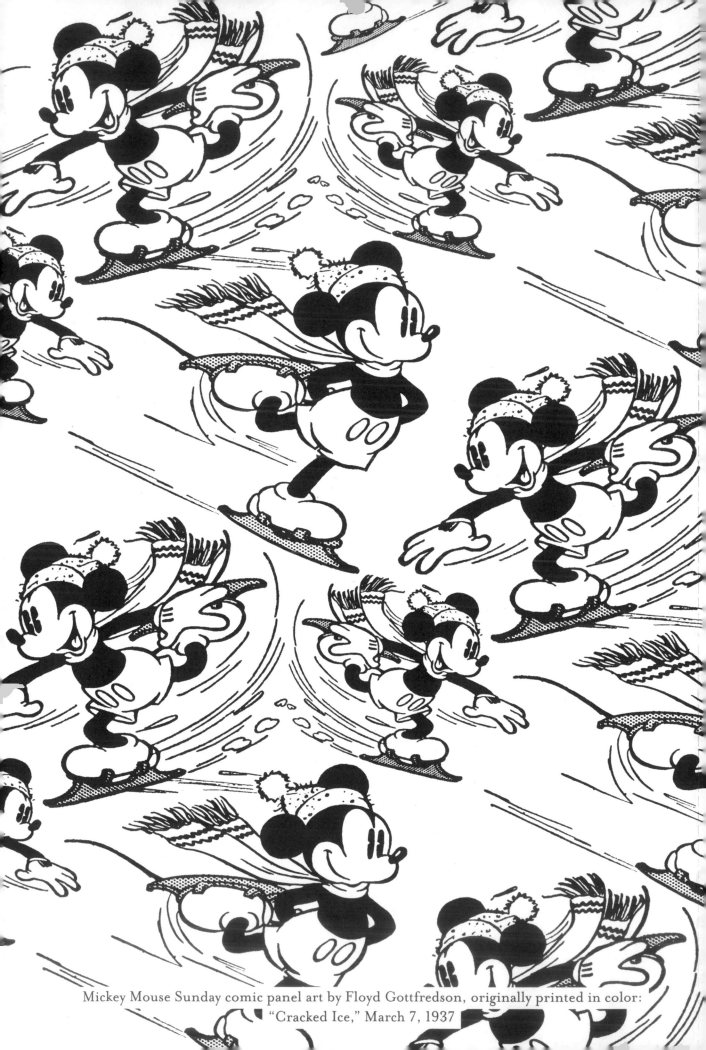

Mickey Mouse Sunday comic panel art by Floyd Gottfredson, originally printed in color:
"Cracked Ice," March 7, 1937

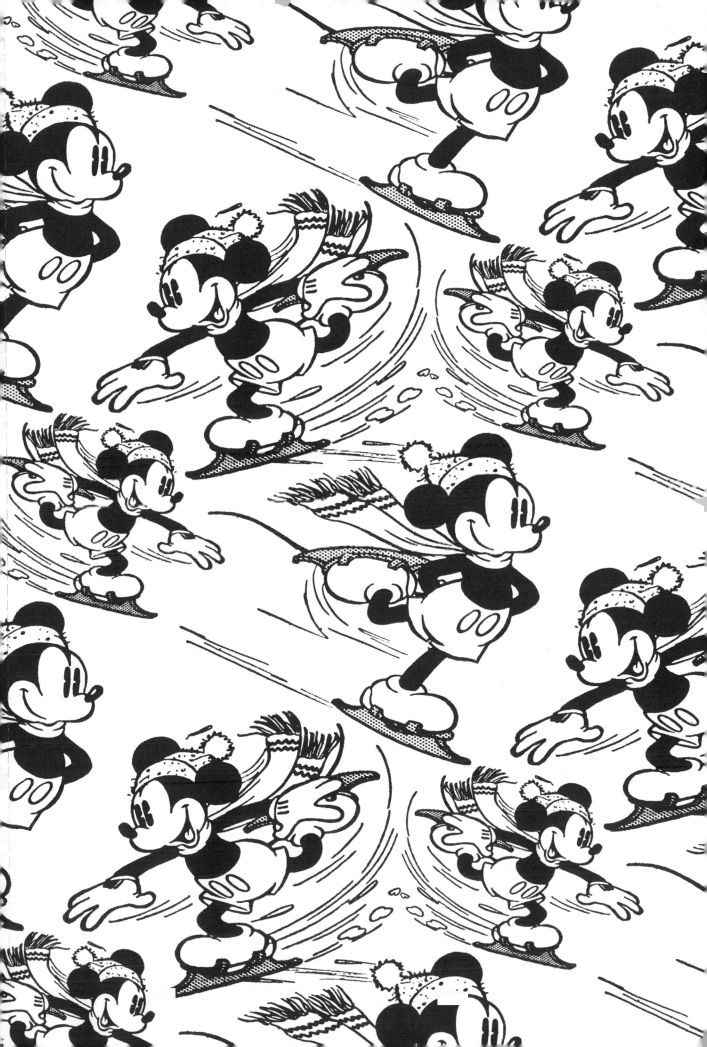

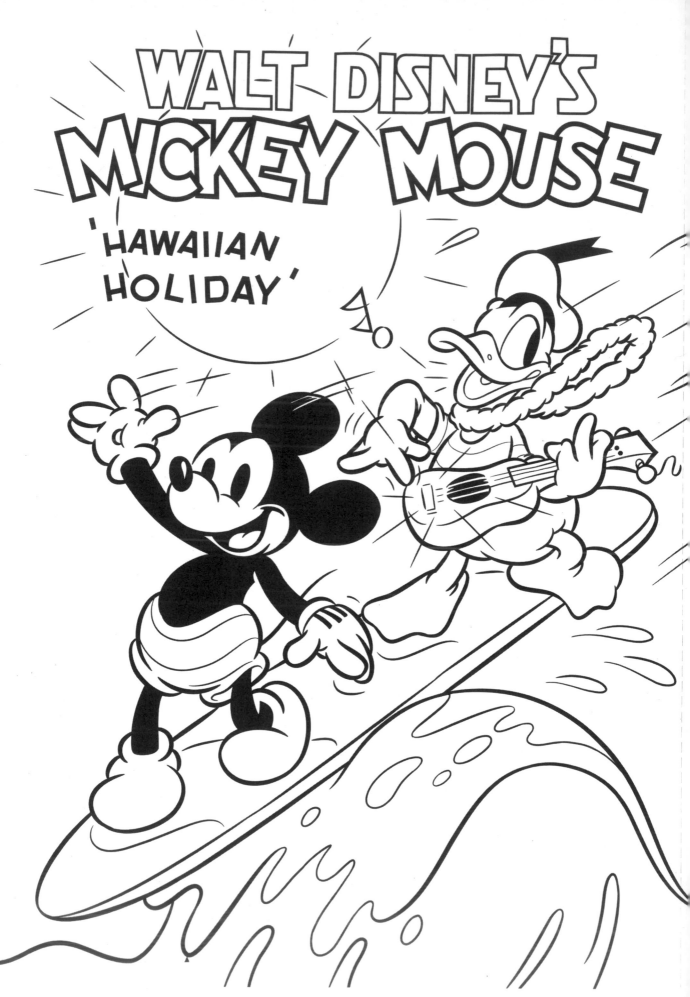

Poster for Mickey Mouse cartoon short: *Hawaiian Holiday*, September 24, 1937

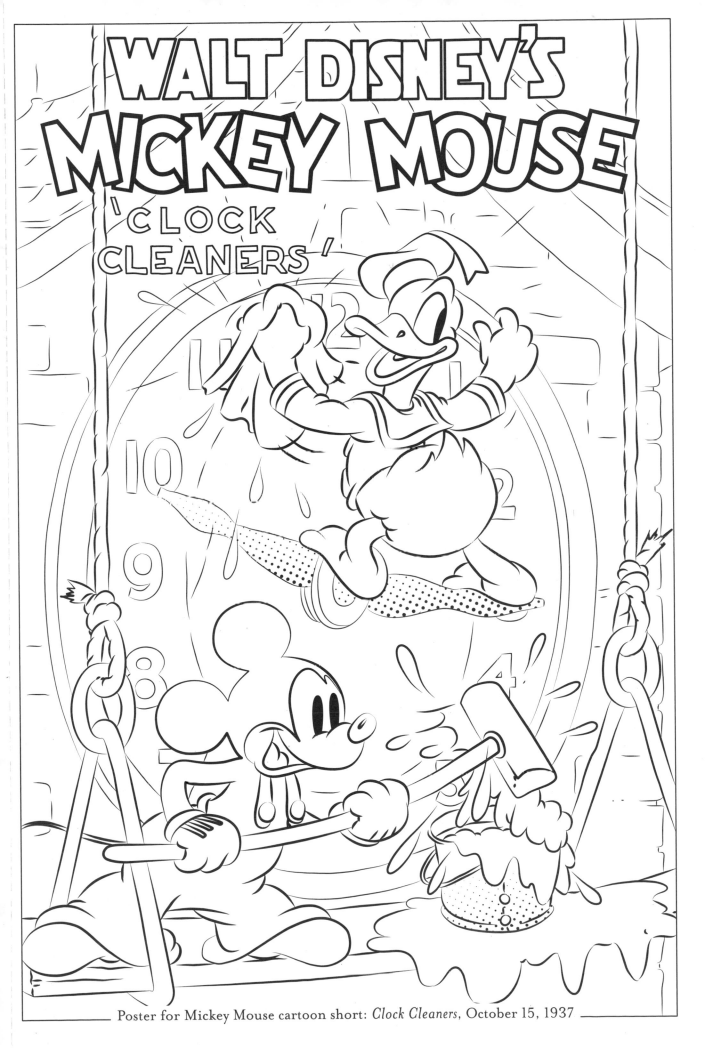

Poster for Mickey Mouse cartoon short: *Clock Cleaners*, October 15, 1937

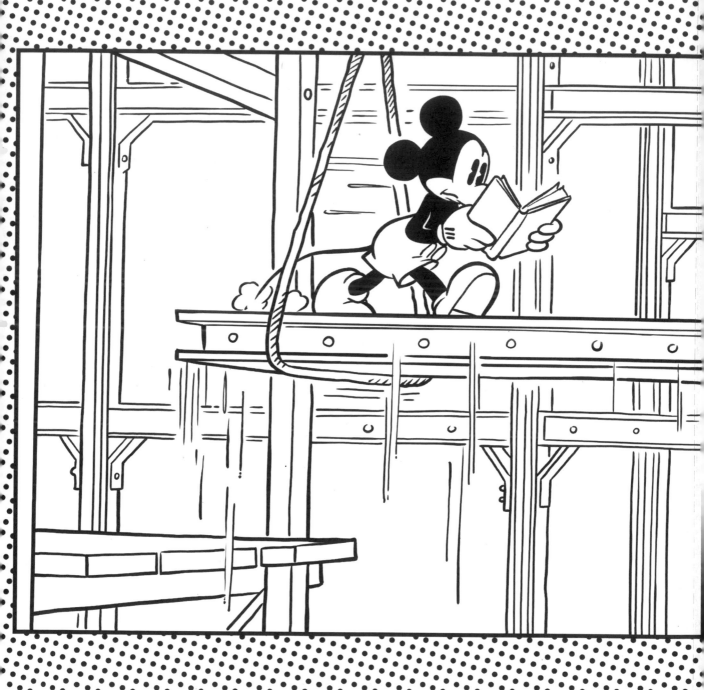

THIS SPREAD AND FOLLOWING SPREAD:
Mickey Mouse Sunday comic panels by Floyd Gottfredson, originally printed in color:
"A Book to Get up in the Air Over," December 5, 1937

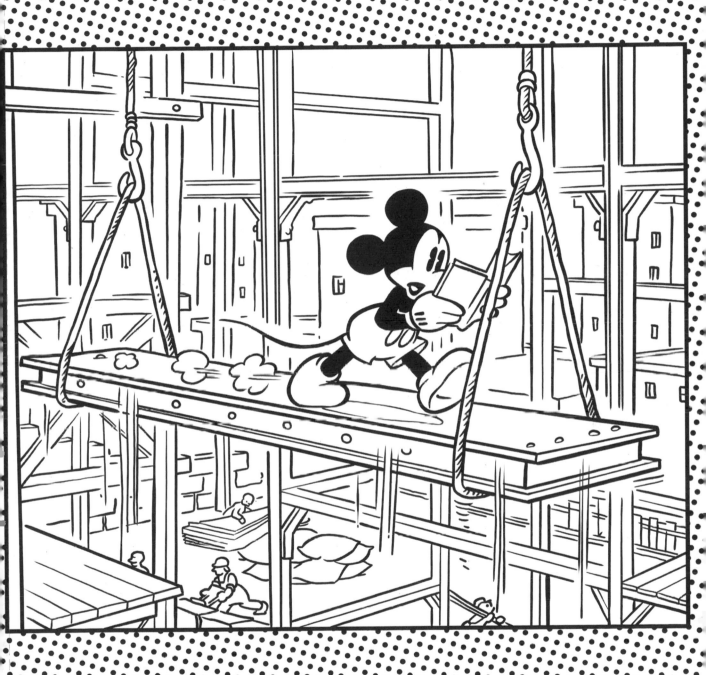

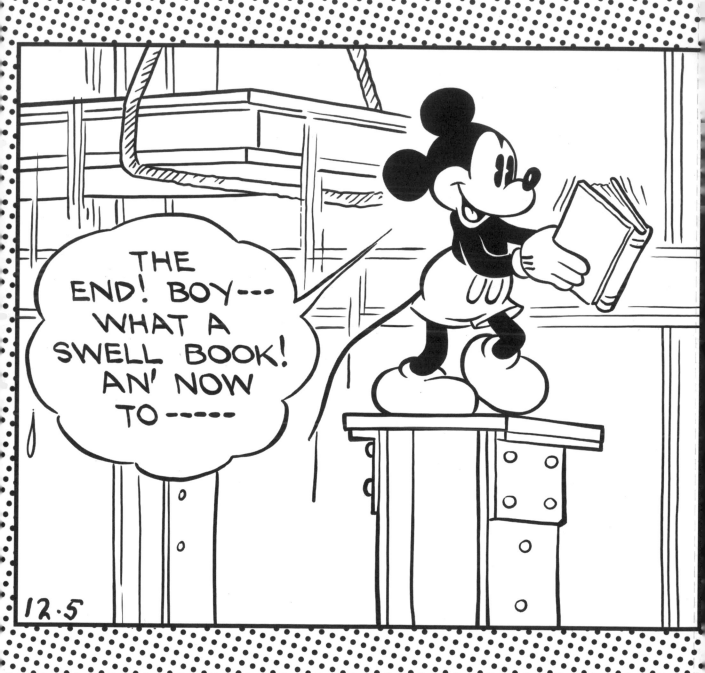

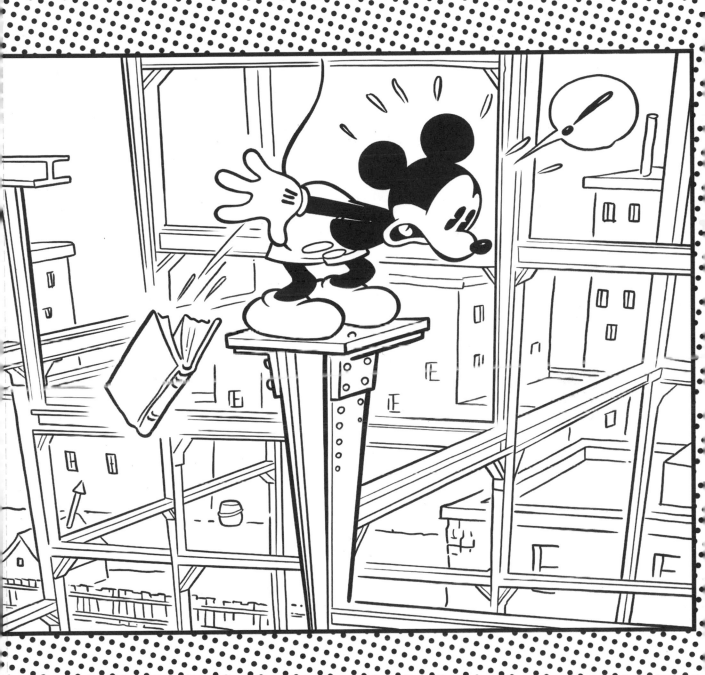

Mickey Mouse Sunday comic panel art by Floyd Gottfredson, originally printed in color:
"A Rolling Pin Gathers No Remorse," February 6, 1938

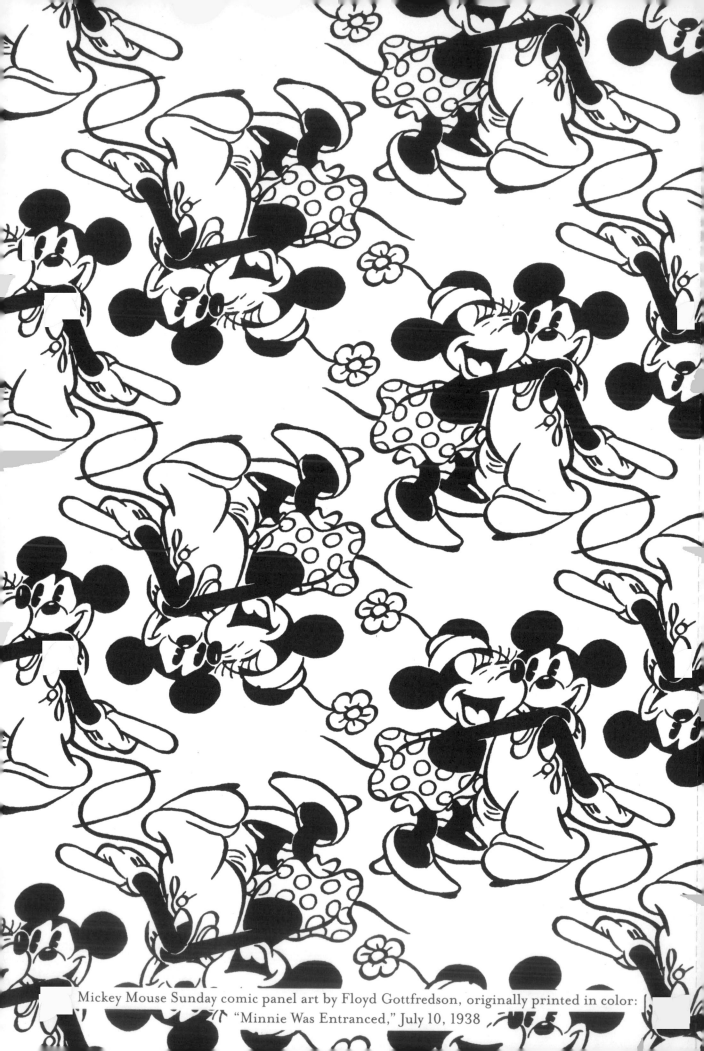

Mickey Mouse Sunday comic panel art by Floyd Gottfredson, originally printed in color: "Minnie Was Entranced," July 10, 1938

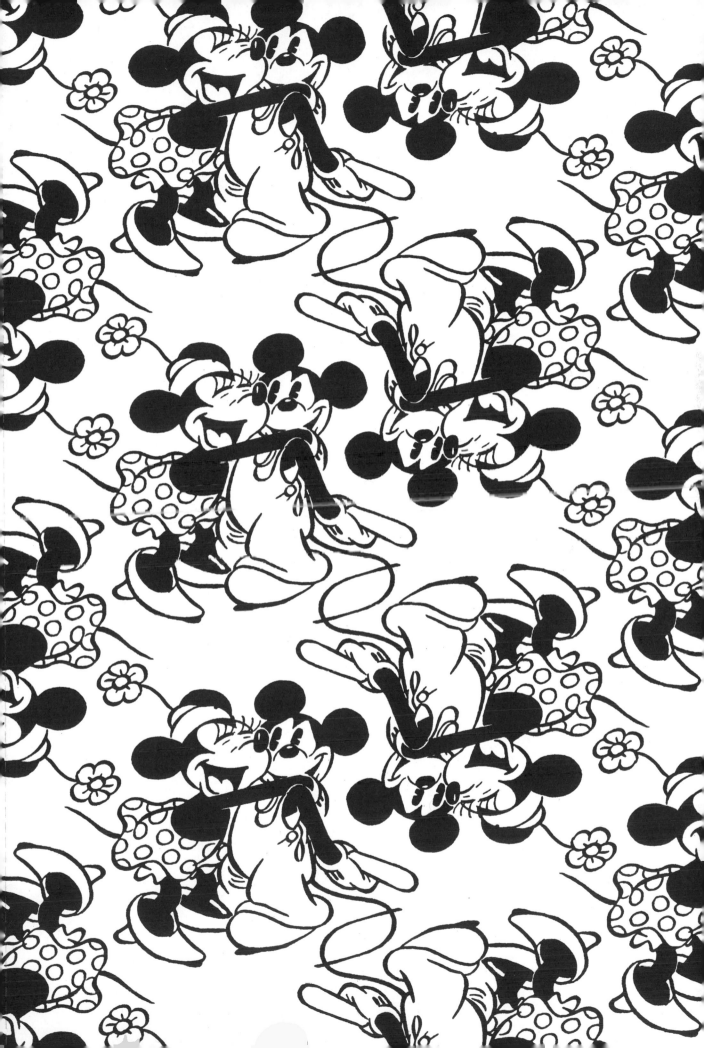

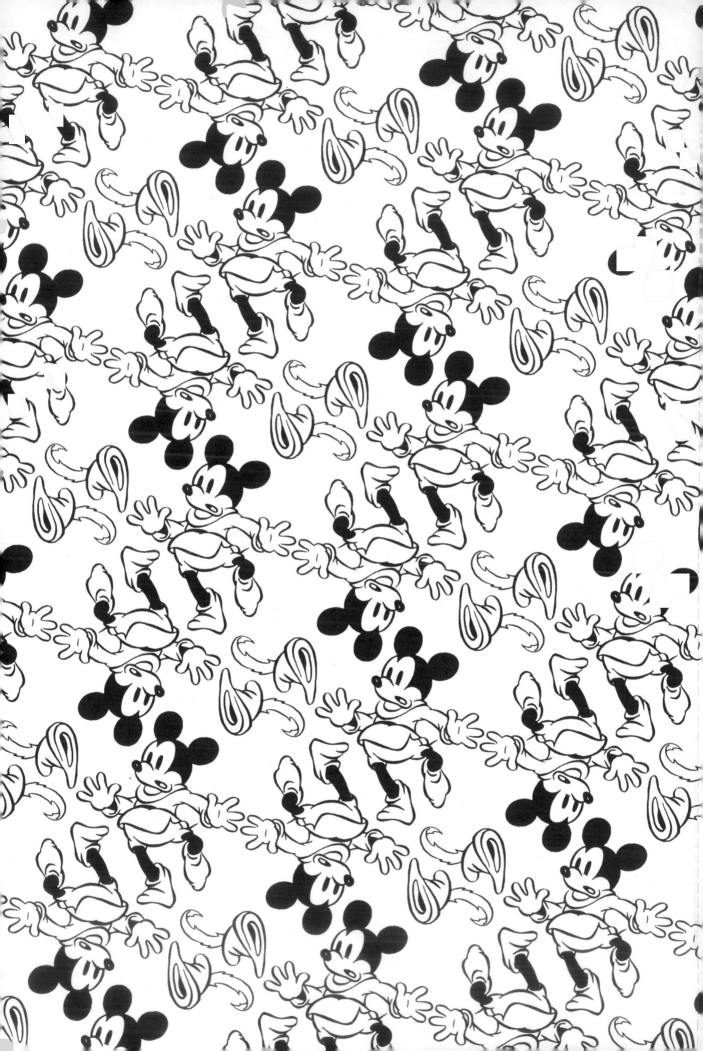

Poster for Mickey Mouse cartoon short: *Brave Little Tailor*, September 23, 1938

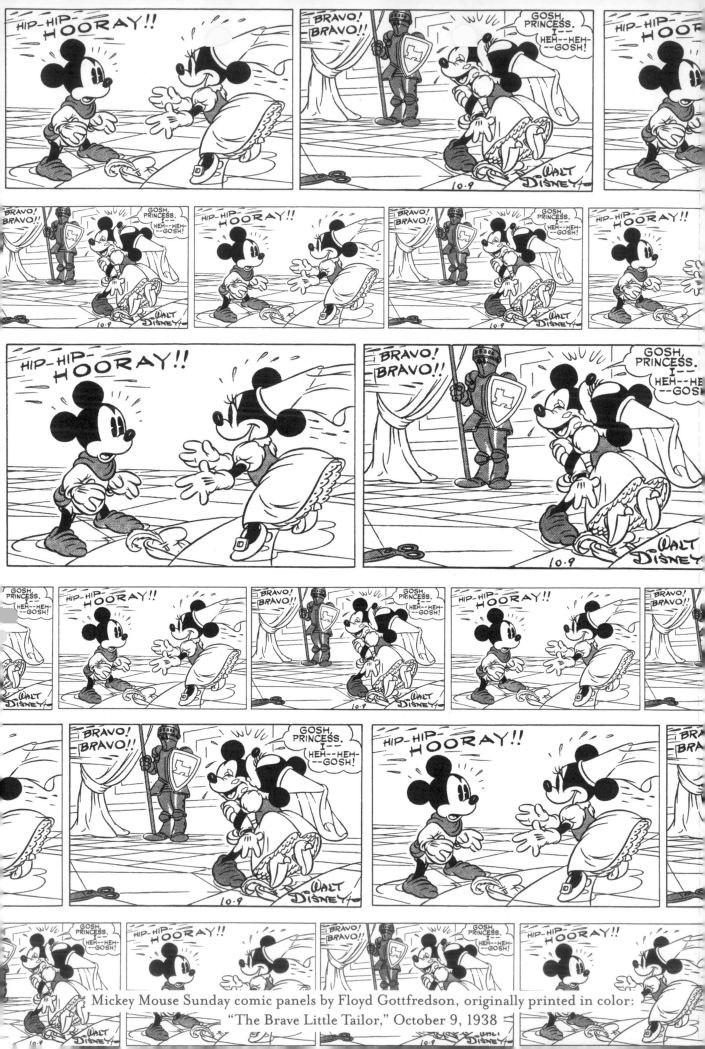

Mickey Mouse Sunday comic panels by Floyd Gottfredson, originally printed in color: "The Brave Little Tailor," October 9, 1938

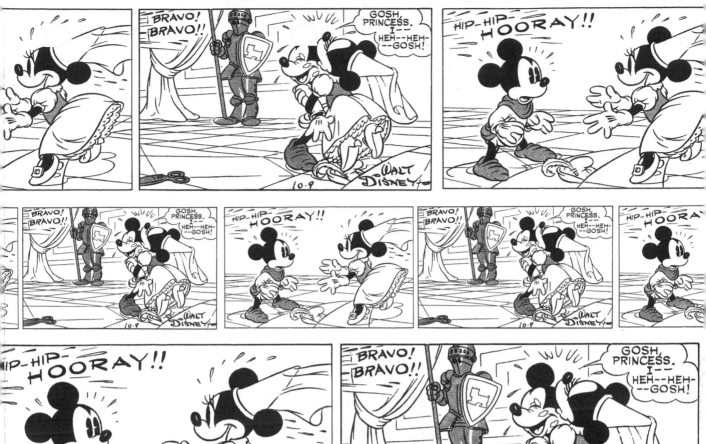
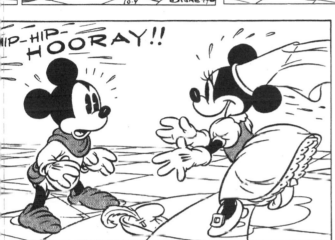
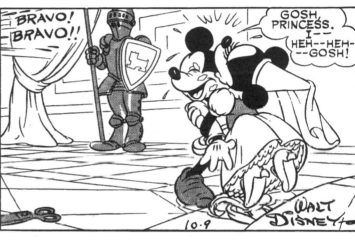

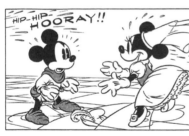
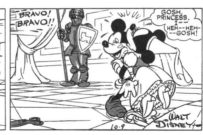
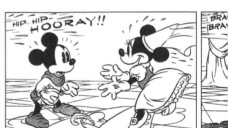
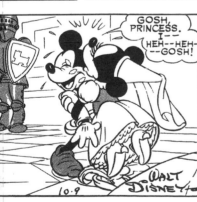
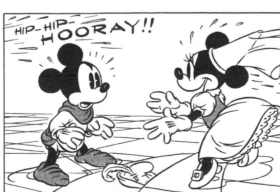
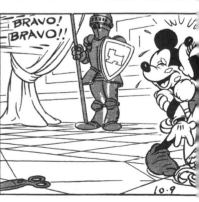
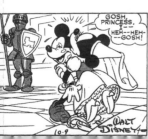
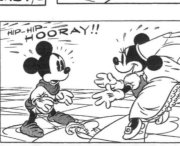

Poster for Mickey Mouse cartoon short: *Society Dog Show*, February 3, 1939

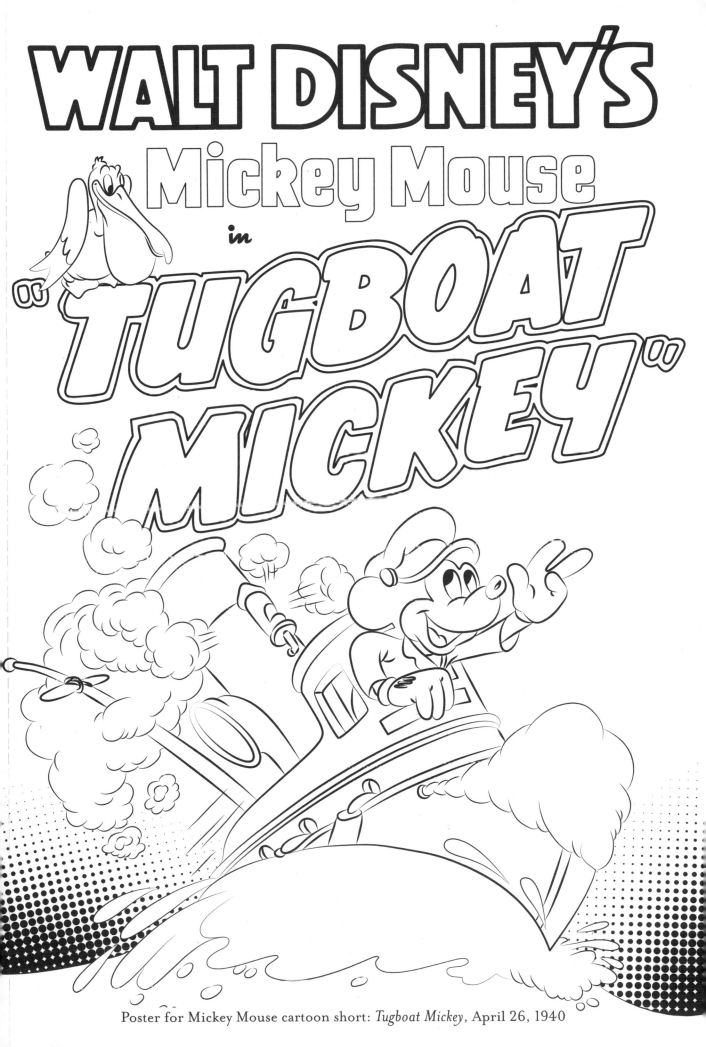

Poster for Mickey Mouse cartoon short: *Tugboat Mickey*, April 26, 1940

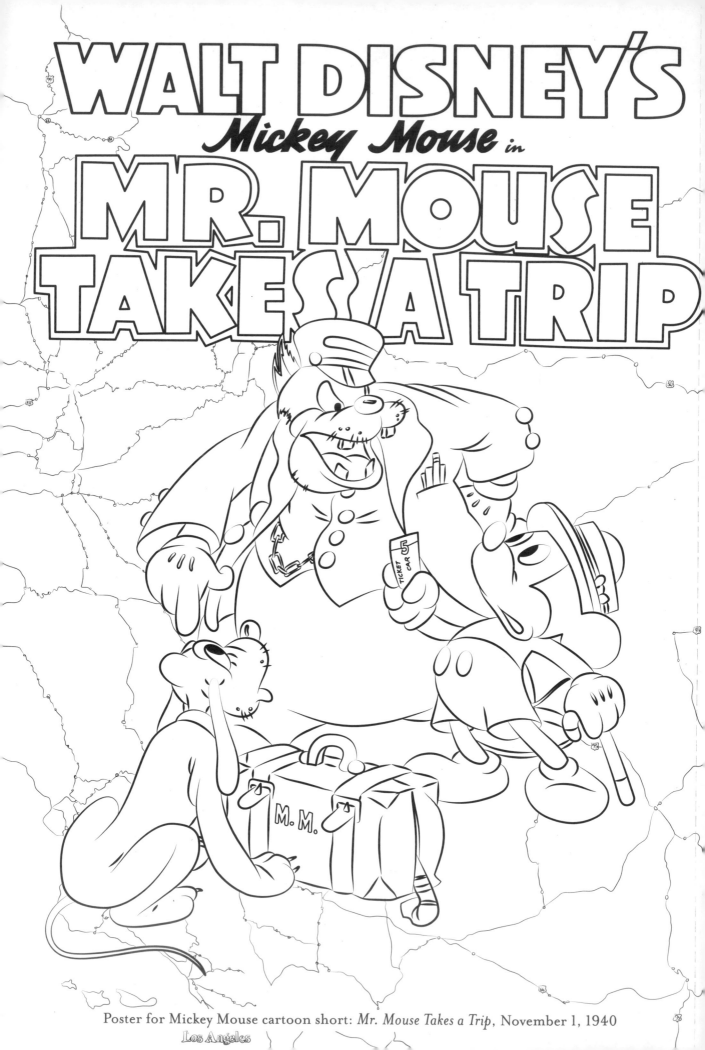

Poster for Mickey Mouse cartoon short: *Mr. Mouse Takes a Trip*, November 1, 1940

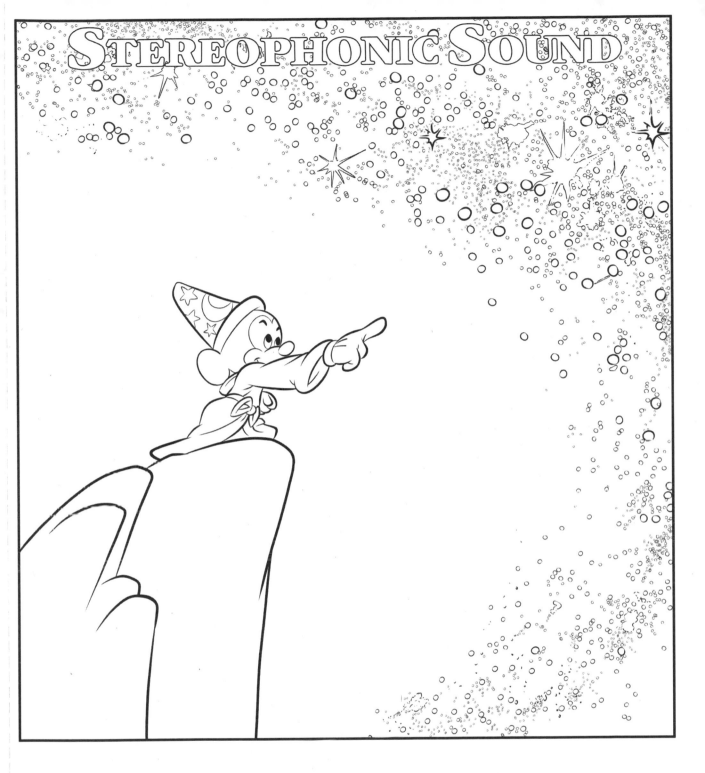

# Walt Disney's Fantasia

## The ultimate in sight and sound

Poster for animated feature: *Fantasia* (highlighting the Mickey Mouse sequence
"The Sorcerer's Apprentice"), November 13, 1940

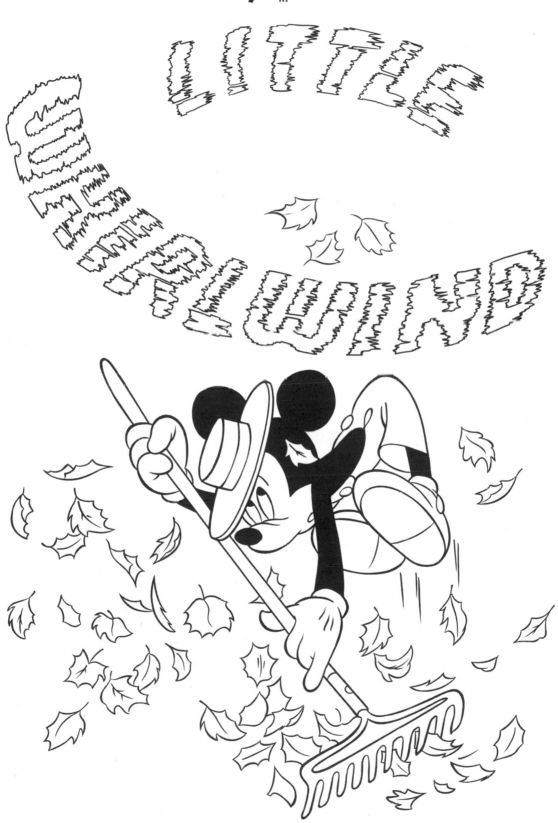

WALT DISNEY'S

*Mickey Mouse*

in

LITTLE WHIRLWIND

Poster for Mickey Mouse cartoon short: *The Little Whirlwind*, February 14, 1941

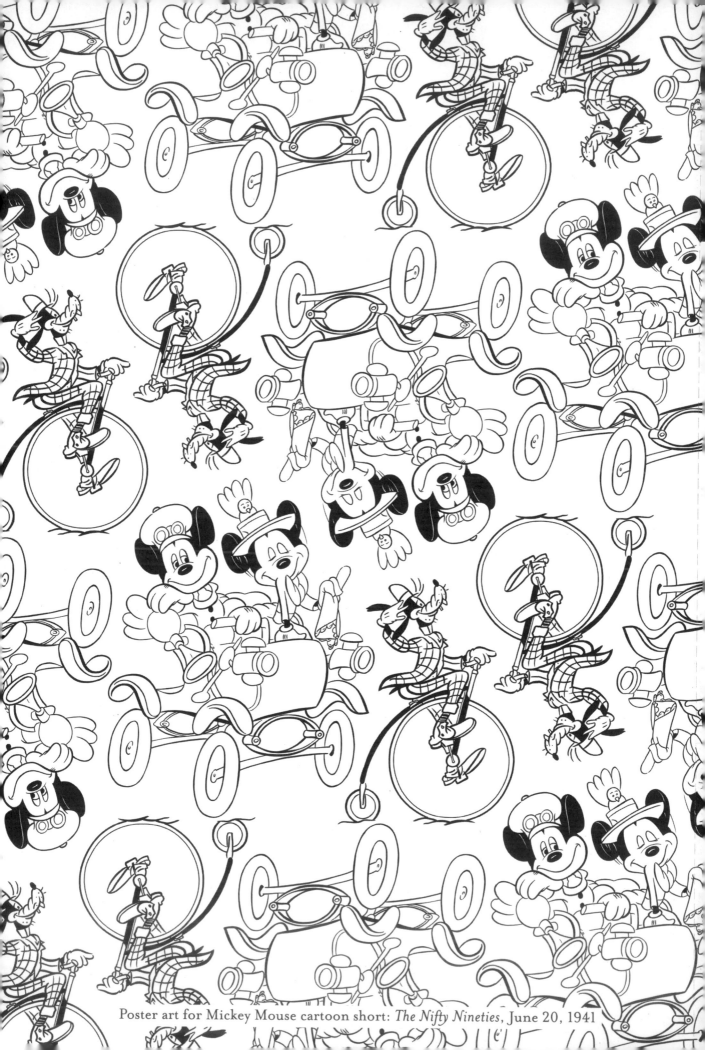

Poster art for Mickey Mouse cartoon short: *The Nifty Nineties*, June 20, 1941

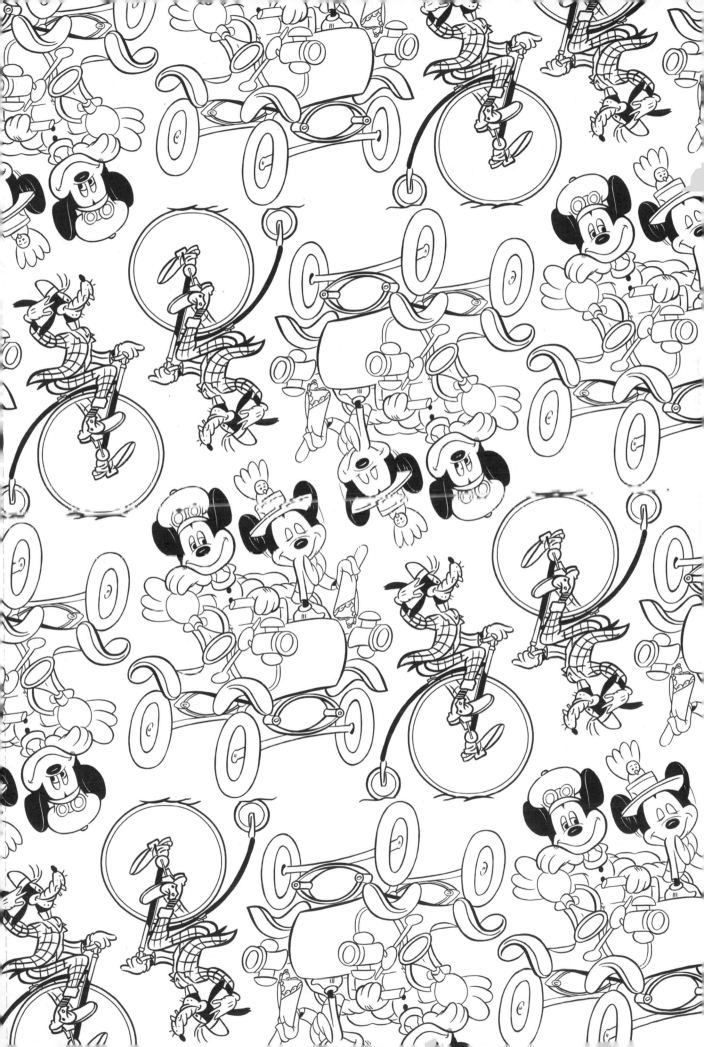

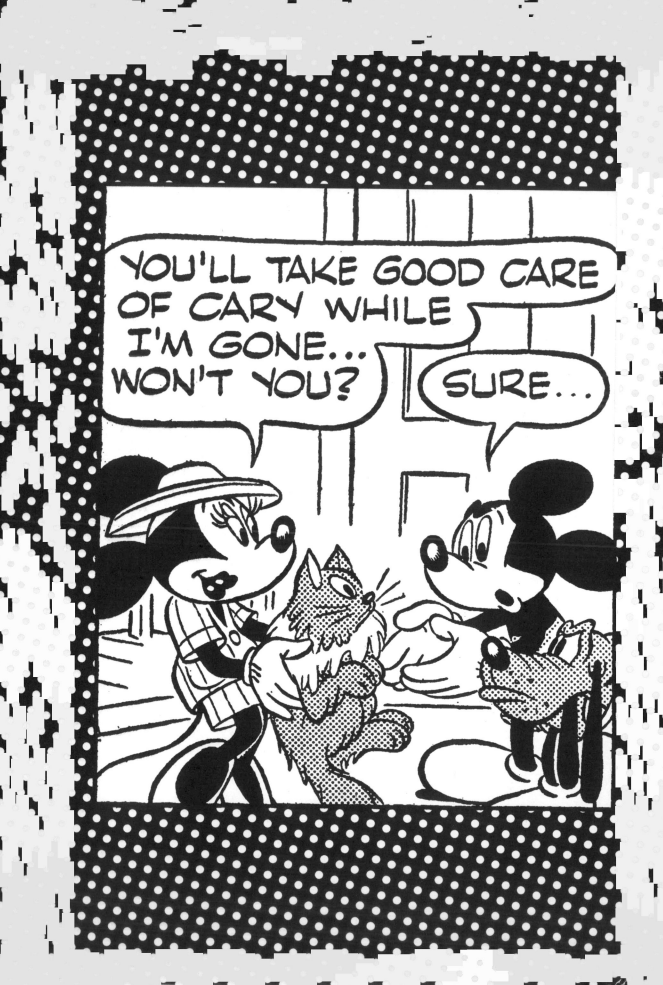

Mickey Mouse comic gag strip panels by Floyd Gottfredson: July 1944

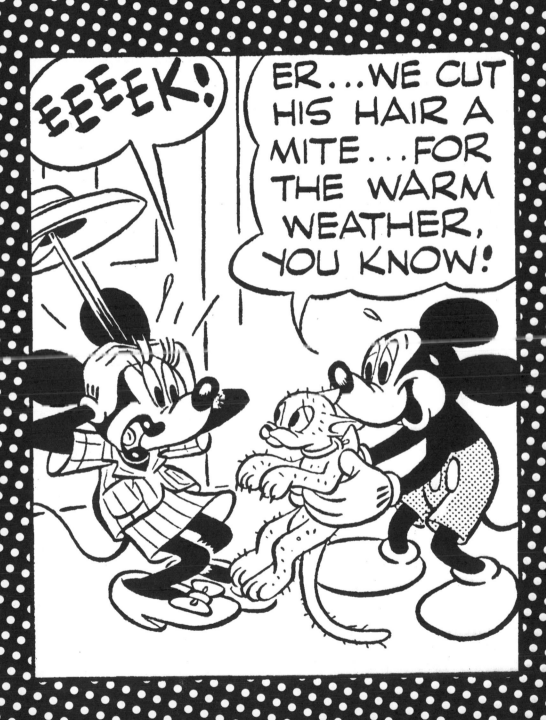

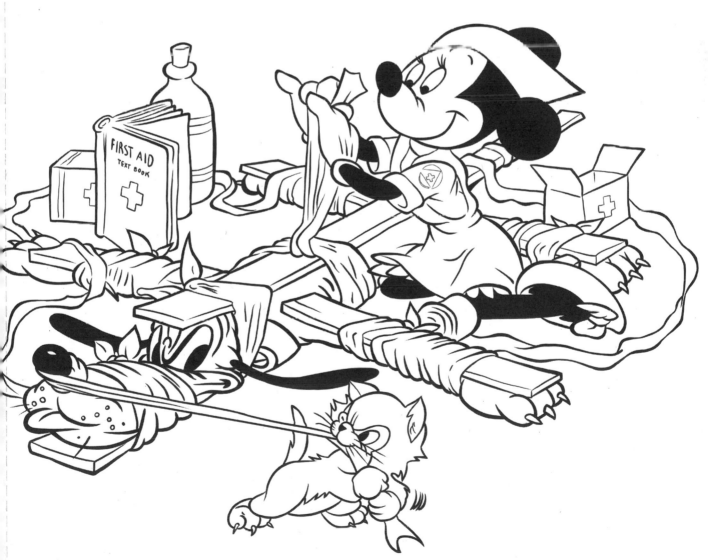

Poster for Pluto cartoon short: *First Aiders*, September 22, 1944

THIS SPREAD: Mickey Mouse comic panel art by Floyd Gottfredson: "The World of Tomorrow," September 23, 1944

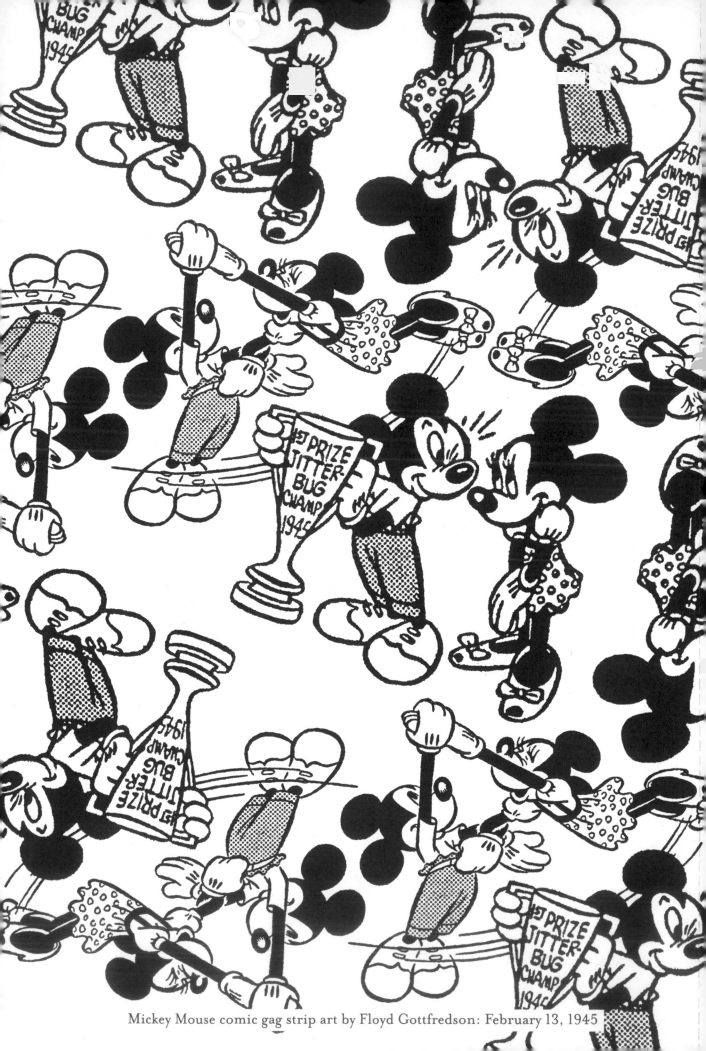

Mickey Mouse comic gag strip art by Floyd Gottfredson: February 13, 1945

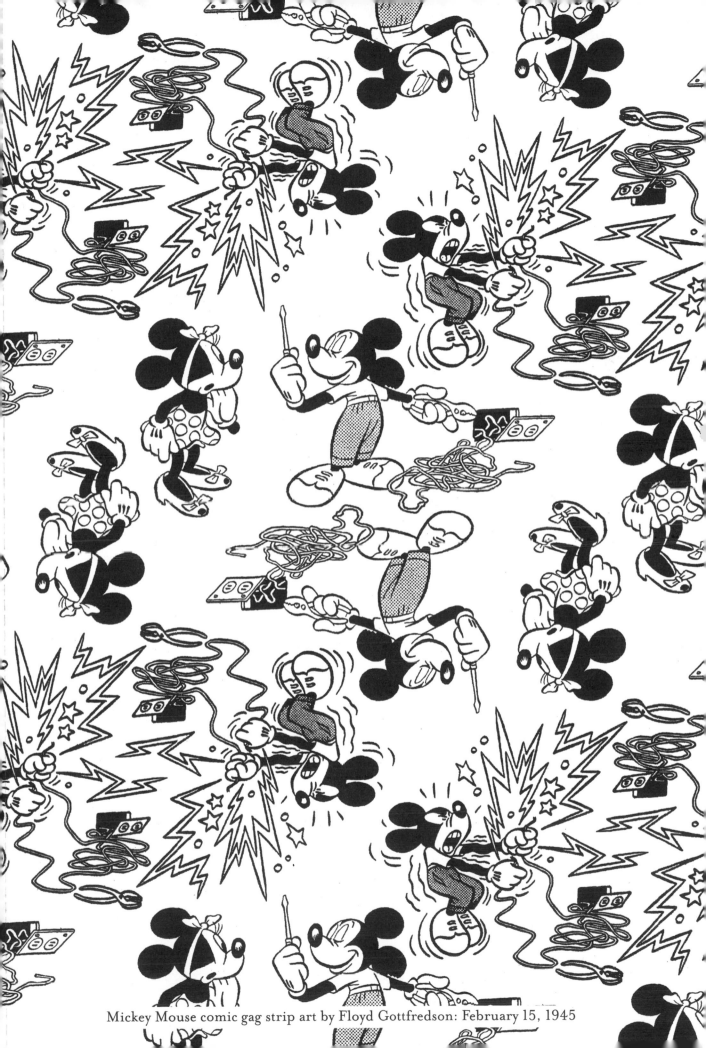

Mickey Mouse comic gag strip art by Floyd Gottfredson: February 15, 1945

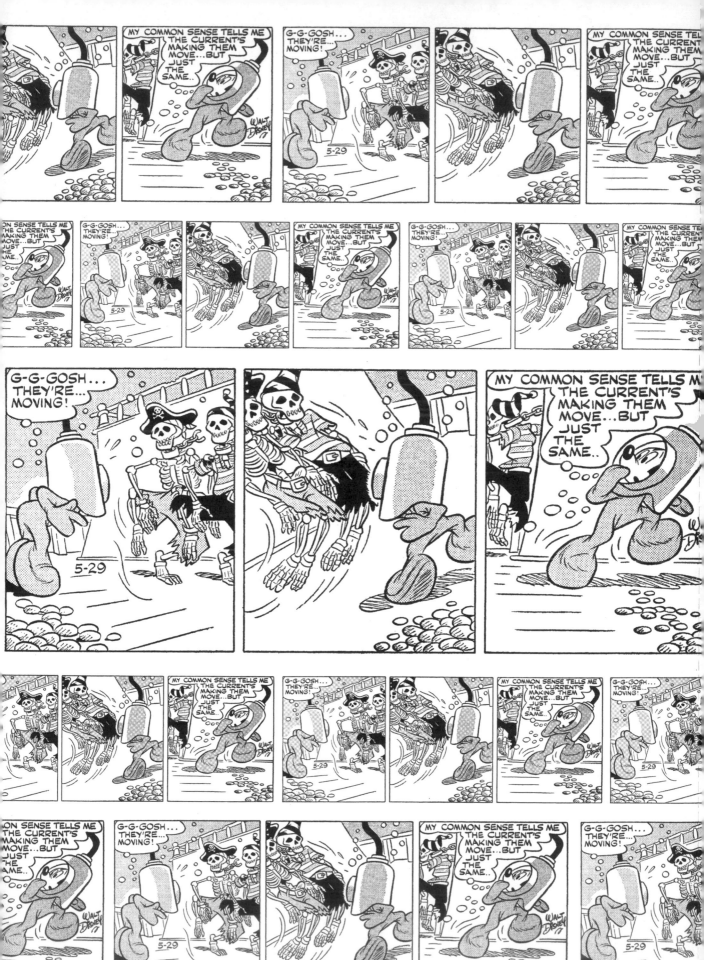

Mickey Mouse comic panels by Floyd Gottfredson: "Sunken Treasure," May 29, 1946

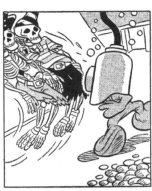
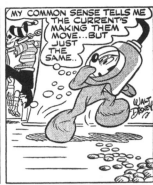
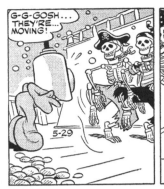
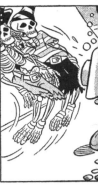

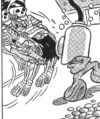
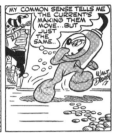
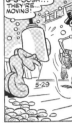

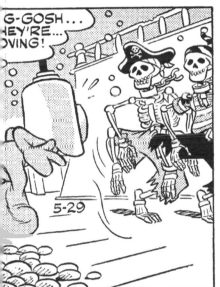
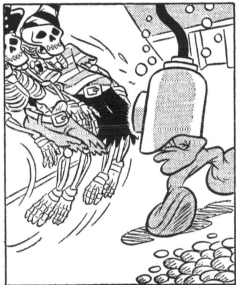
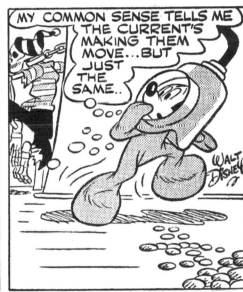

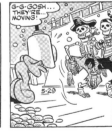
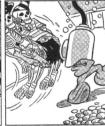
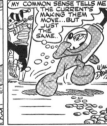
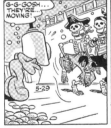

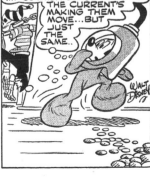
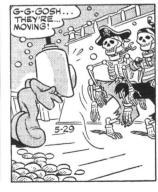

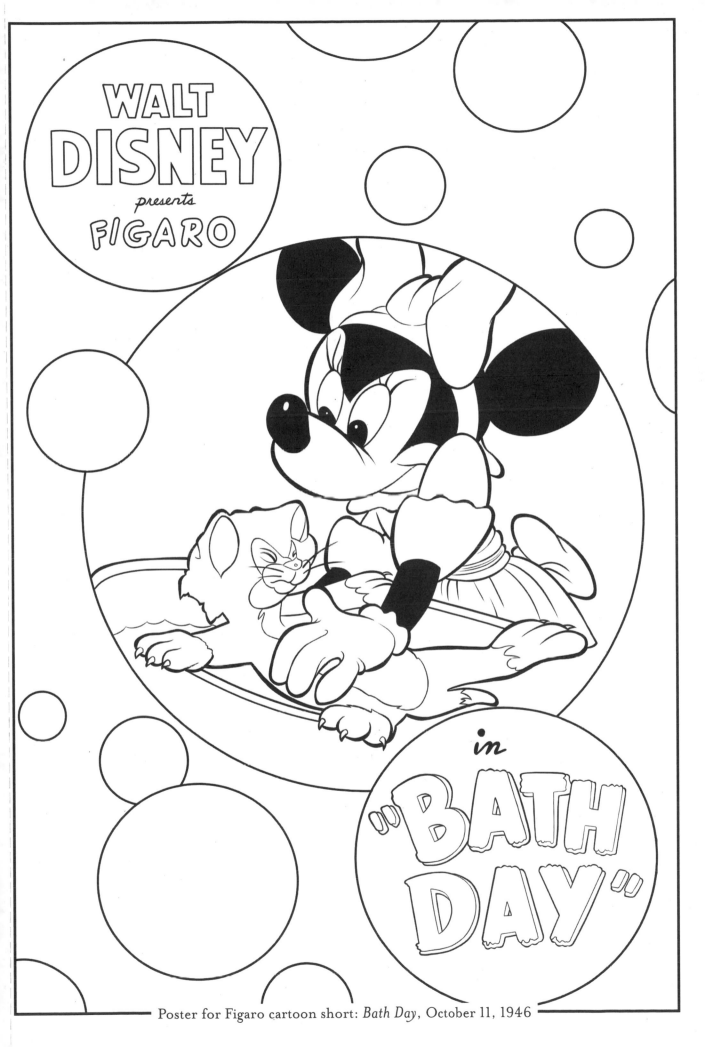

Poster for Figaro cartoon short: *Bath Day*, October 11, 1946

Mickey Mouse comic panel art by Floyd Gottfredson: "The Cure for Hiccups," October 18, 1946

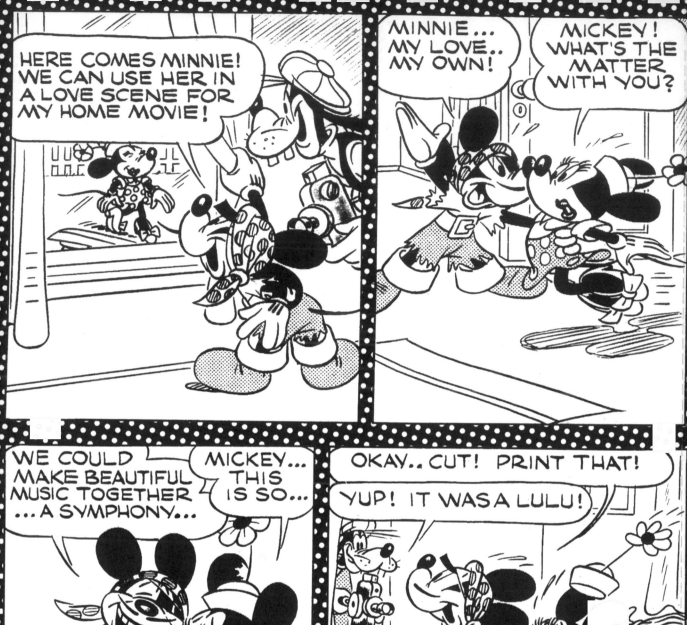

Mickey Mouse comic panels by Floyd Gottfredson: "Home Movies," March 25, 1947

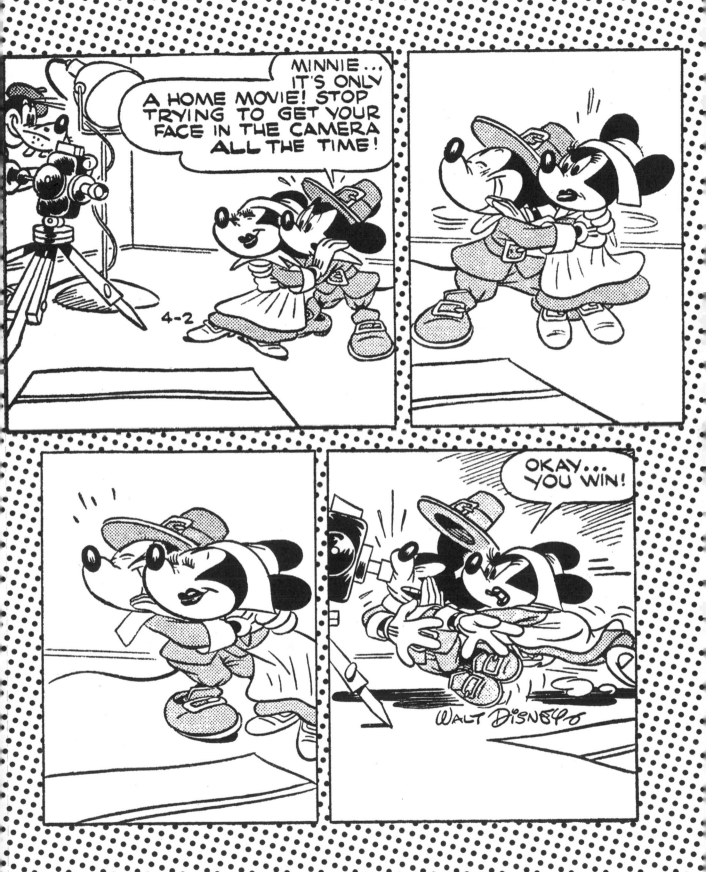

Mickey Mouse comic panels by Floyd Gottfredson: "Home Movies," April 2, 1947

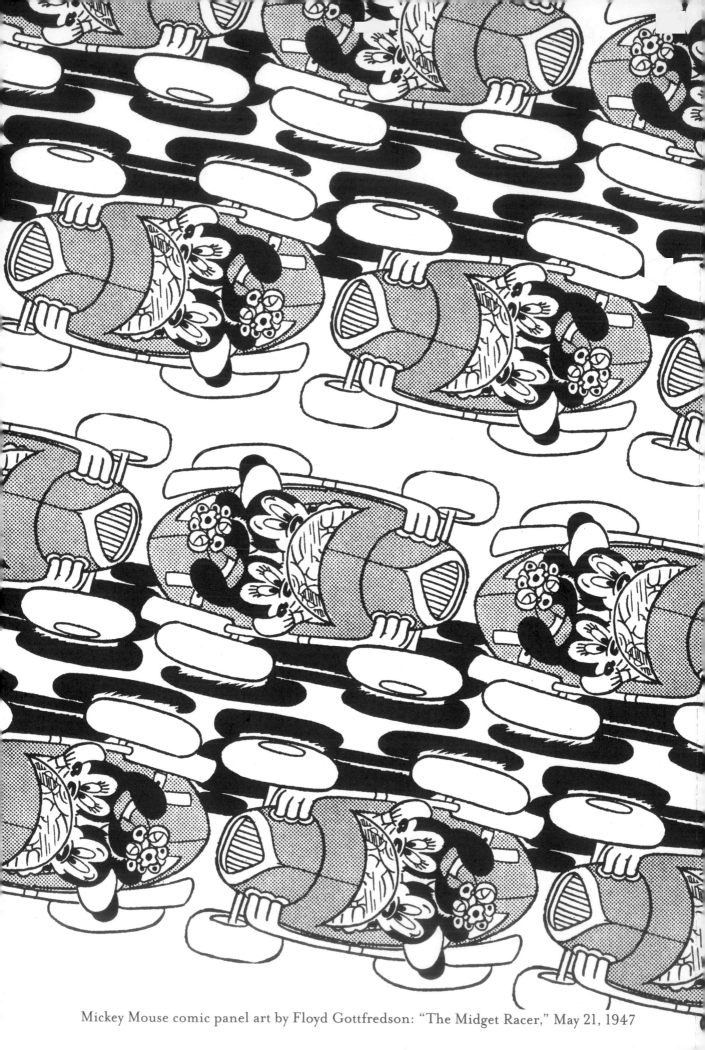

Mickey Mouse comic panel art by Floyd Gottfredson: "The Midget Racer," May 21, 1947

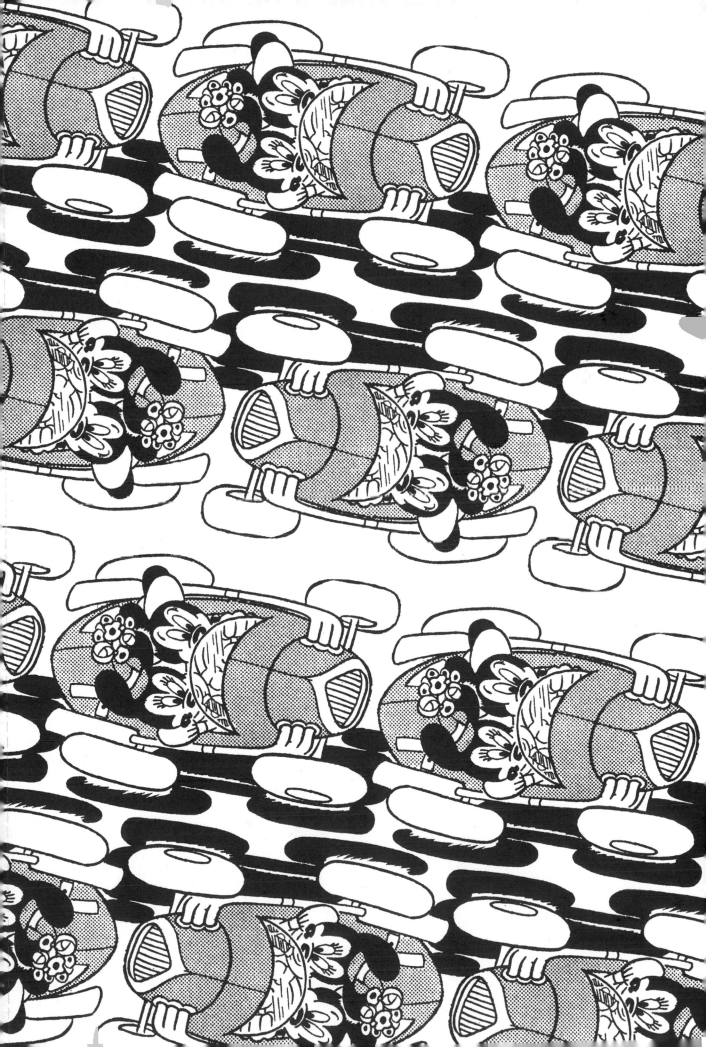

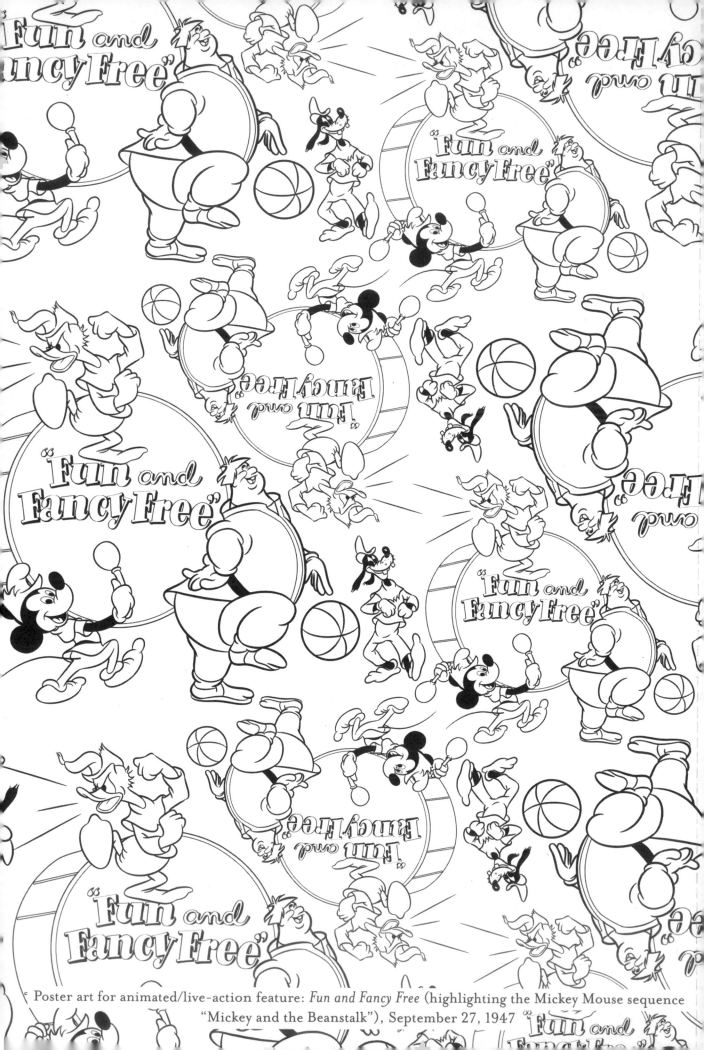

Poster art for animated/live-action feature: *Fun and Fancy Free* (highlighting the Mickey Mouse sequence "Mickey and the Beanstalk"), September 27, 1947

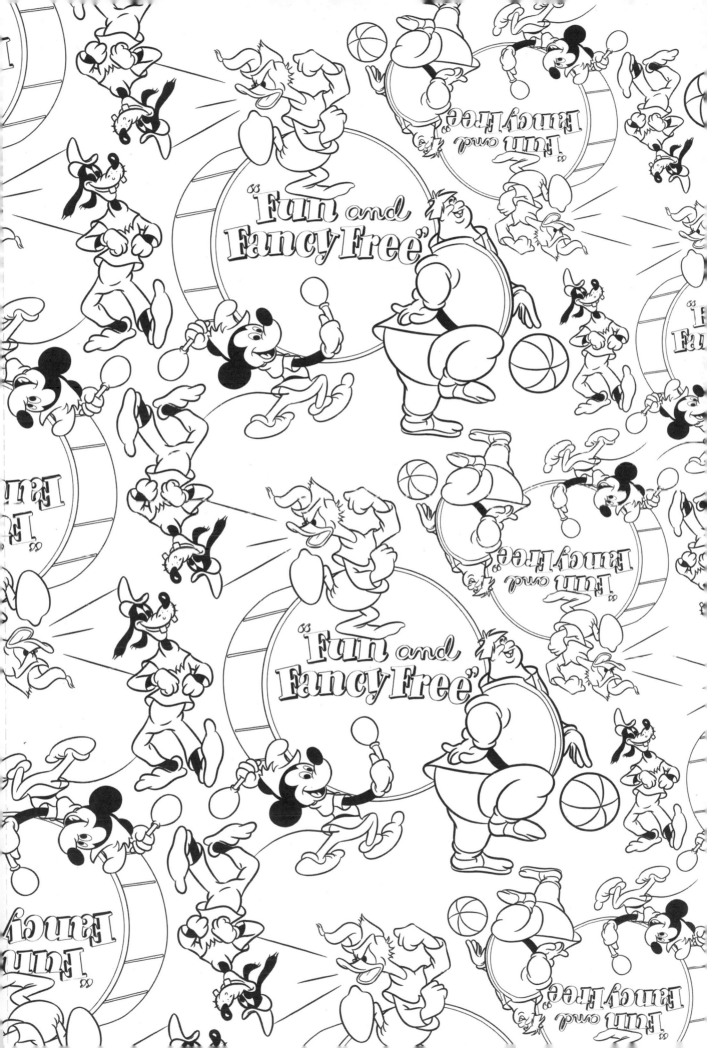

Mickey Mouse comic panel art by Floyd Gottfredson: "The Man of Tomorrow," October 18, 1947

Mickey Mouse comic panel art by Floyd Gottfredson: "Mickey Makes a Killing," January 15, 1948

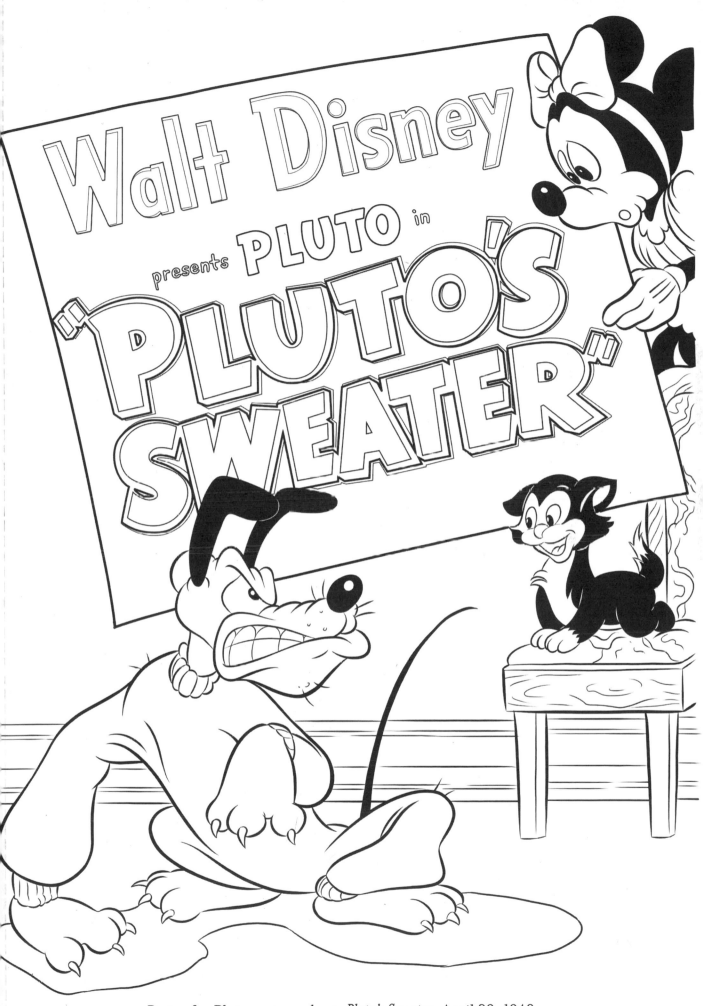

Poster for Pluto cartoon short: *Pluto's Sweater*, April 29, 1949

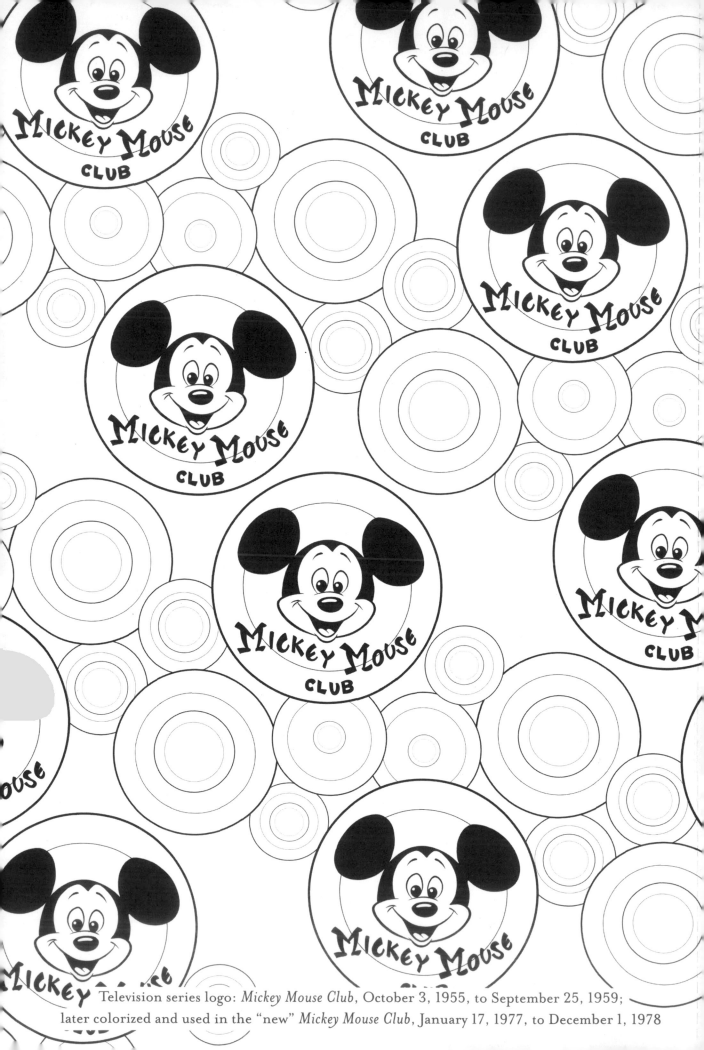

Television series logo: *Mickey Mouse Club*, October 3, 1955, to September 25, 1959; later colorized and used in the "new" *Mickey Mouse Club*, January 17, 1977, to December 1, 1978

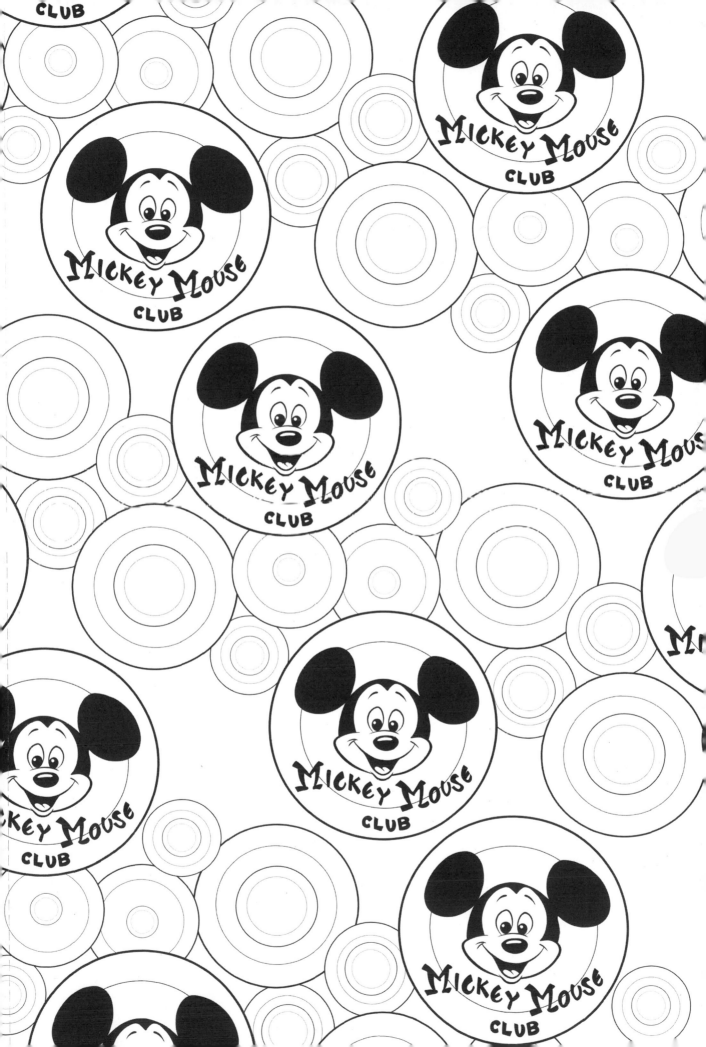

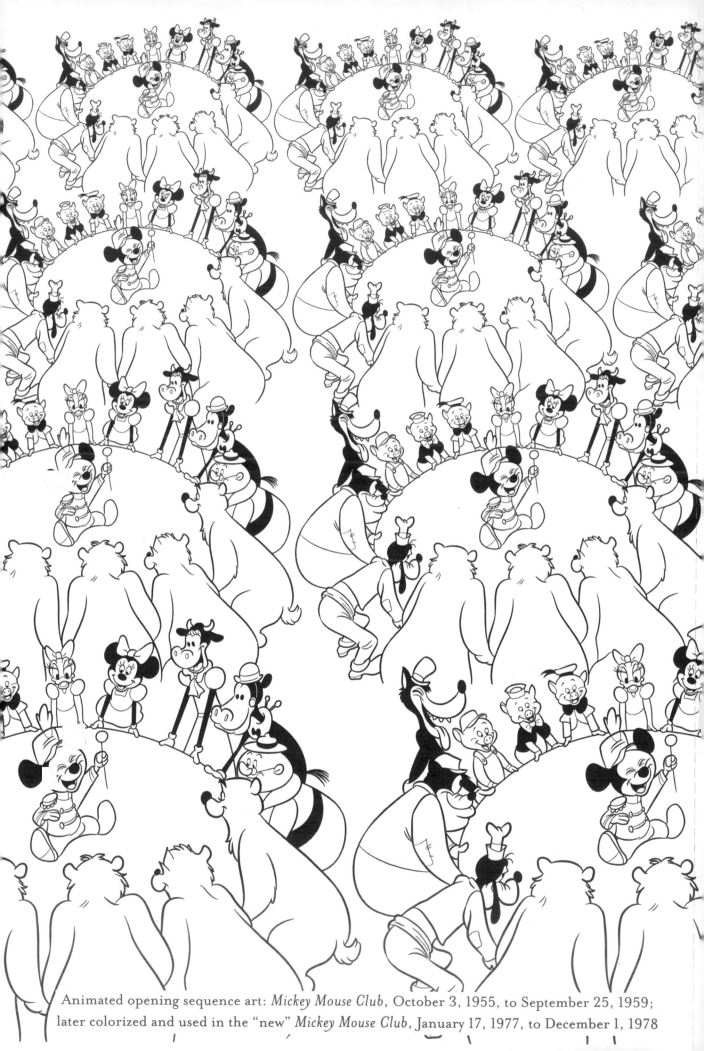

Animated opening sequence art: *Mickey Mouse Club*, October 3, 1955, to September 25, 1959;
later colorized and used in the "new" *Mickey Mouse Club*, January 17, 1977, to December 1, 1978

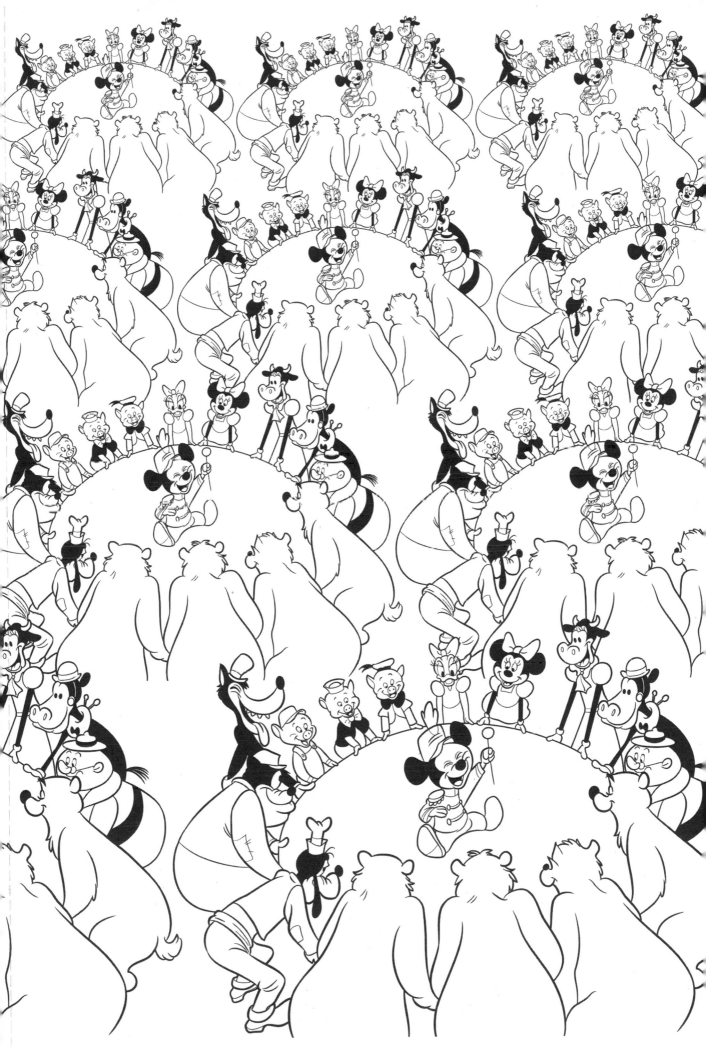

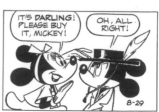

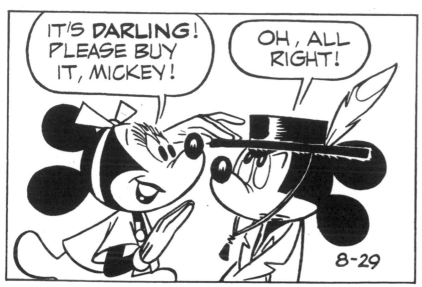

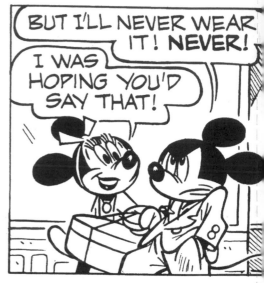

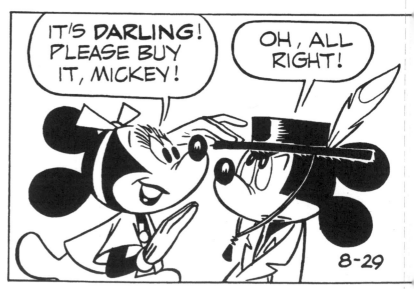

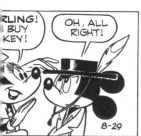
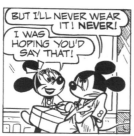

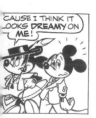

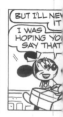

Mickey Mouse Sunday comic panels by Floyd Gottfredson, originally printed in color:
"Hat Check," August 29, 1976

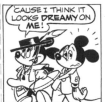
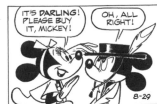
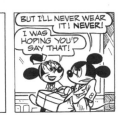

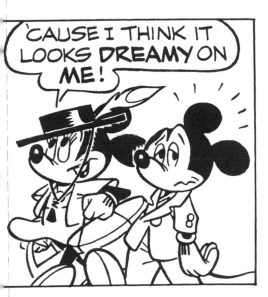
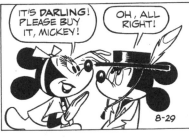
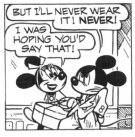
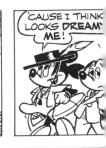

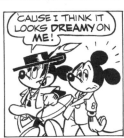
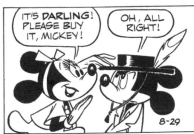
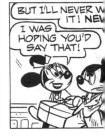

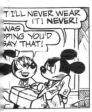
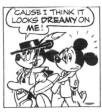
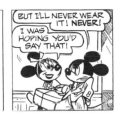
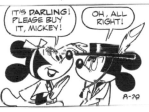
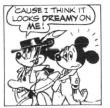
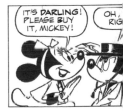

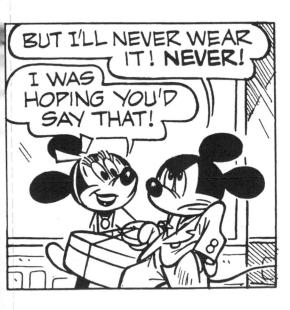
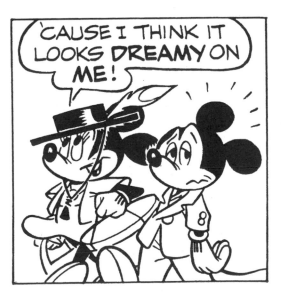

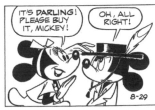
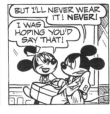
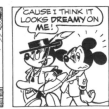
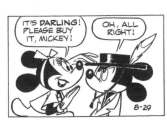

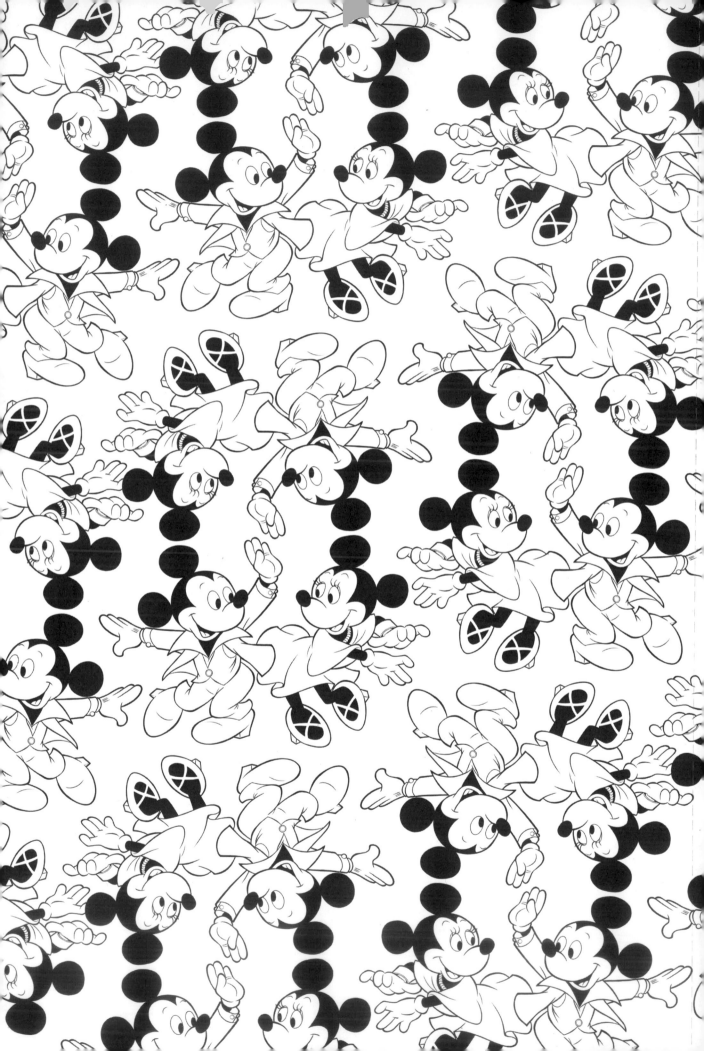

Poster for animated television music video compilation featuring classic Disney cartoon shorts:
*Mickey Mouse Disco*, June 25, 1980

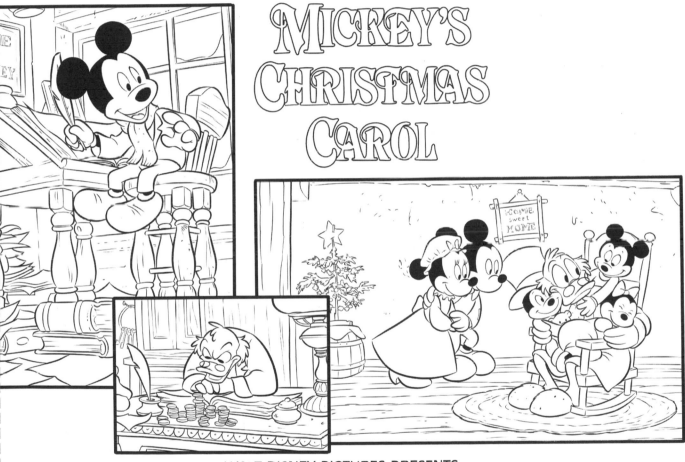

Poster for Mickey Mouse cartoon featurette: *Mickey's Christmas Carol*, December 16, 1983

Poster art for Mickey Mouse cartoon featurette: *Mickey's Christmas Carol*, December 16, 1983

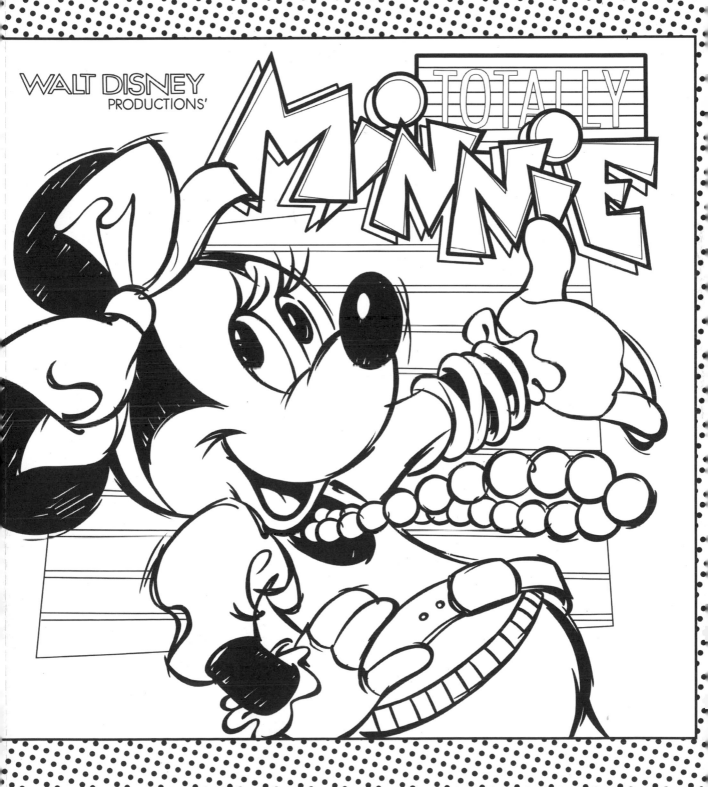

Disneyland Records album cover: *Totally Minnie*, 1986

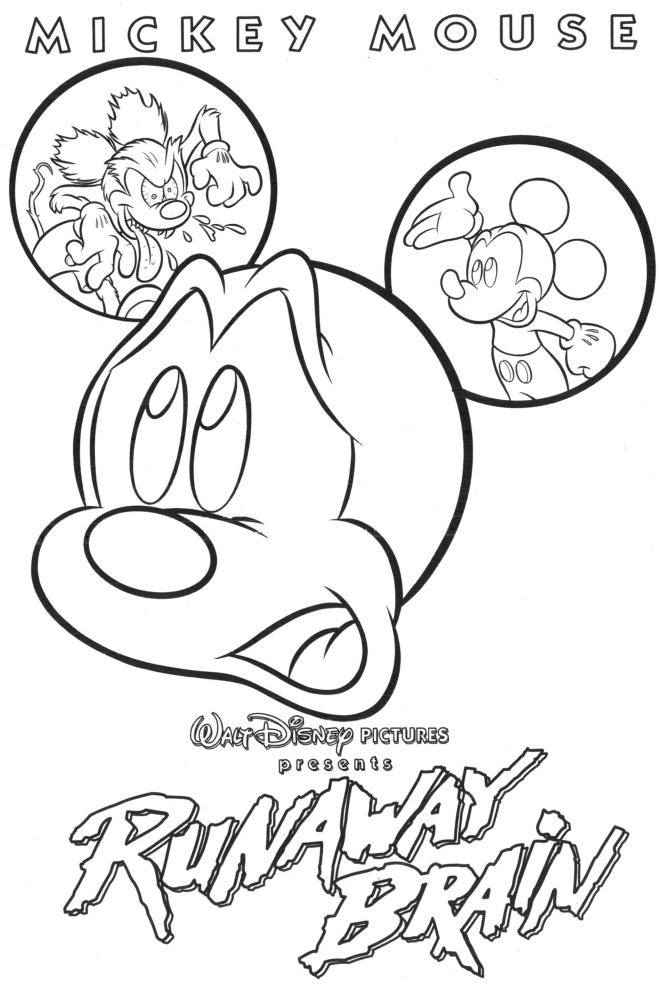

Poster for Mickey Mouse cartoon short: *Runaway Brain*, August 11, 1995

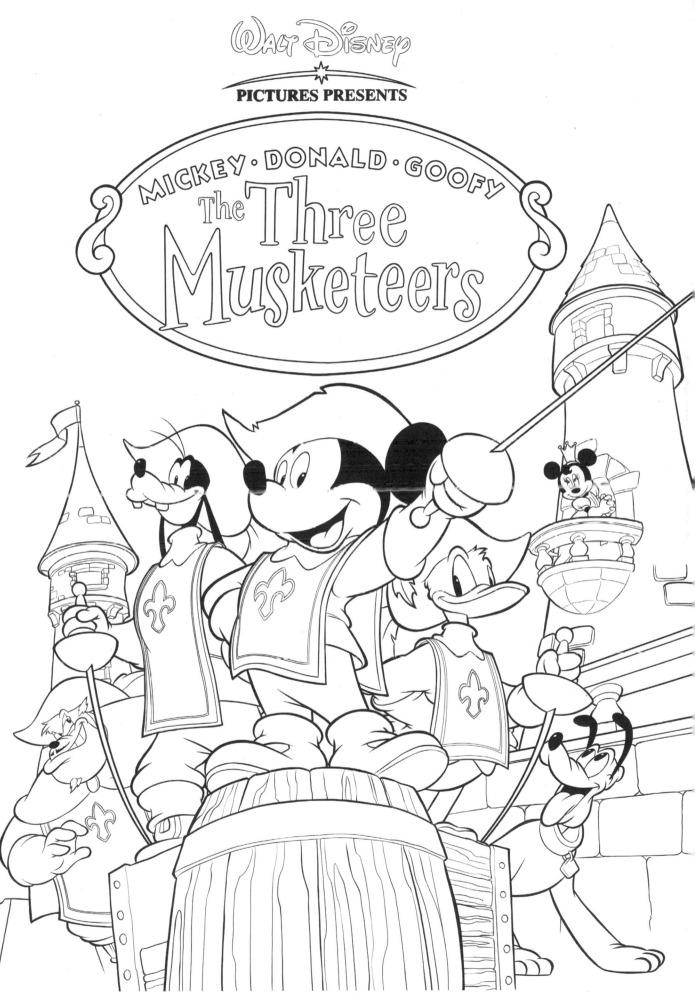

Box cover for direct-to-home-video animated feature: *The Three Musketeers*, August 17, 2004

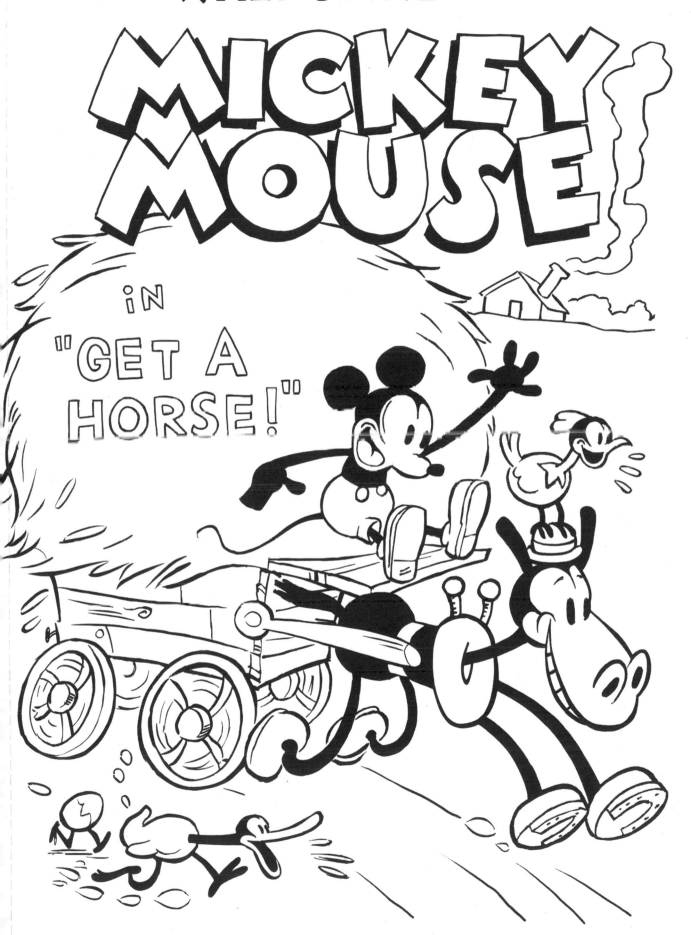

Poster for Mickey Mouse cartoon short: *Get a Horse!*, November 27, 2013

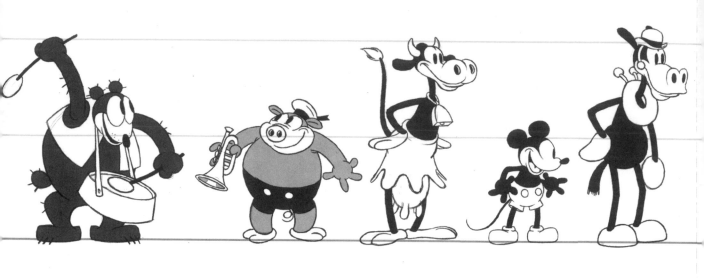

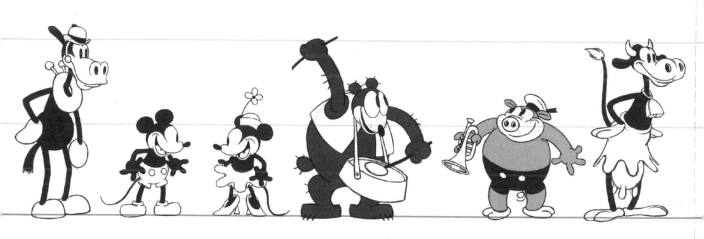

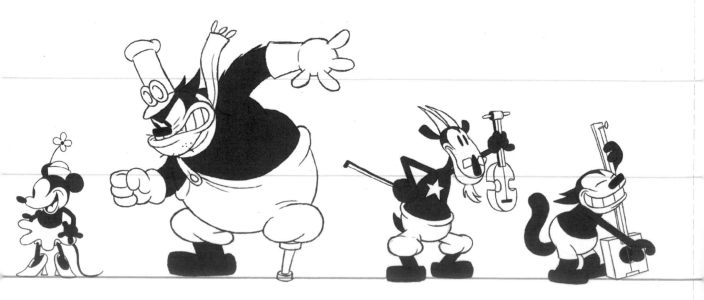

Character lineup art by Eric Goldberg illustrating the characters' height differences in the Mickey Mouse short *Get a Horse!*, November 27, 2013

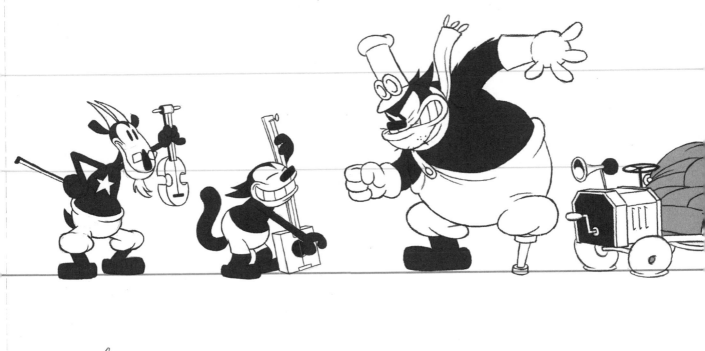
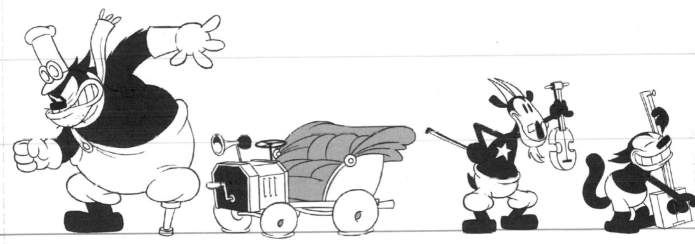
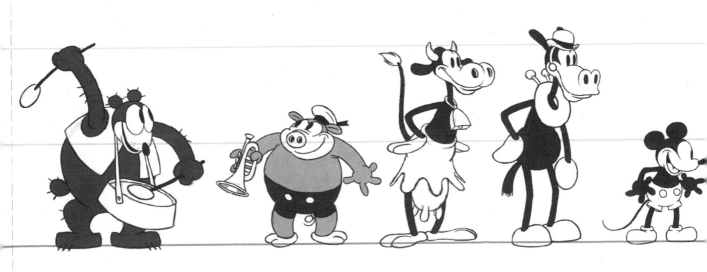

Character art for television series: *Mickey Mouse*, which was released online, on Disney Channel, and on additional formats beginning 2013

# Relax

## and let the creativity flow through you.

Fans of all ages will enjoy these stunning pen-and-ink illustrations.

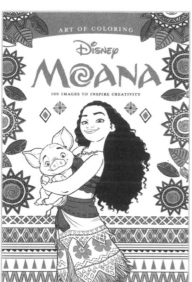

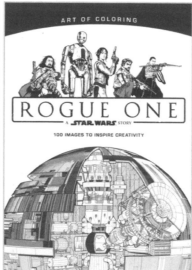

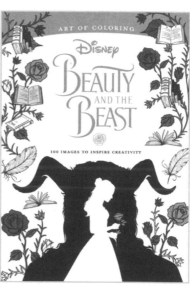

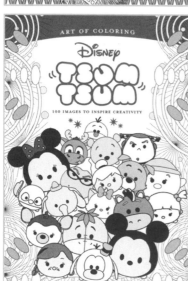

## Collect them all today.